Perspective
in Art

Perspective
in Art

Michael Woods

NORTH LIGHT BOOKS

Cincinnati, Ohio

To my wife Jacqueline

ACKNOWLEDGMENT

Tuition from a drawing master may be for a matter of hours or extend over a period of years. I would like to acknowledge my debt to those who taught me—in particular John Marshall, Leslie Davenport, Sam Carter, Edward Ardizone, Sir William Coldstream and Sir Thomas Monnington.

0–89134–226–5

Printed in Great Britain

Contents

Introduction

Drawing conjures up a scene of calm contentment; the artist working away without a care in the world. Yet, for some, art is a formidable subject which seems only within the grasp of the gifted few. This need not be the case, however, for anyone can learn to draw, provided, of course, they wish to be taught. Some may achieve success more quickly than others, and one aspect of successful drawing is an understanding of perspective.

1 *The artist working*

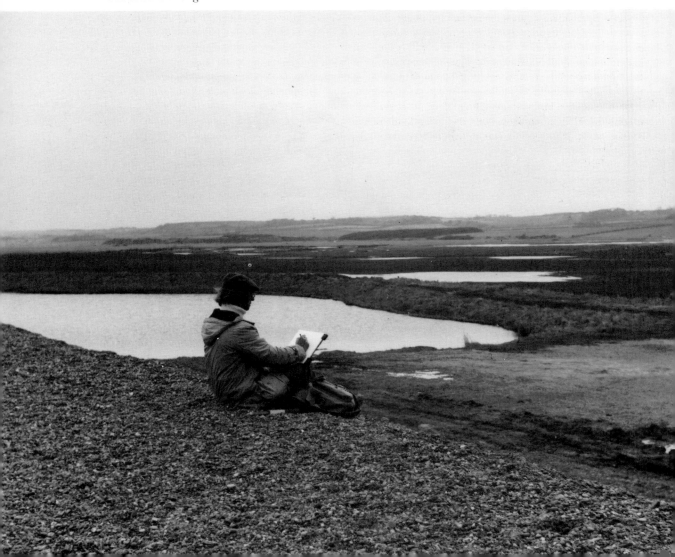

A strange look of concern frequently comes over a listener when the word 'perspective' is used in a conversation about art. It is as if the subject is not quite nice and should be regarded with suspicion. As an art teacher, I often find myself explaining how much freedom comes from having an awareness of perspective. I put it precisely like that—an awareness—for I am not referring to the mathematical construction of objects in perspective, but rather the ability to understand what happens to the appearance of objects when they are presented to the eye. Knowledge of perspective alerts the eye. The brain muddles us sometimes, for it is almost too clever and we are reluctant to give up our knowledge of the environment, or the formulae for objects which we have learnt.

So bearing in mind that all which follows suggests a way of thinking and understanding, of giving approximate guides and a sequence of development, it is possible to embark on a series of exciting discoveries which I hope will give further enthusiasm to the artist already working, and encouragement to those as yet less skilled.

Take the example of a very simple, regular cube—a big dice for instance (Fig. 2). The brain understands that all the sides are the same length and are at right angles to one another; that two

2 *A simple dice*

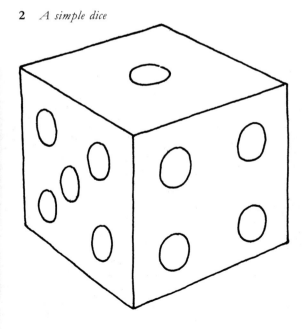

3 *Plan of sides*

sides will be parallel (Fig. 3). Now, due to the effect of perspective, when a view of more than one side is taken, the edges, known to be parallel, will appear to converge as they travel away from the eye (Fig. 4). I have noticed that, for those whose experience in drawing is limited, their attempt to draw this object invariably results in some of the lines being made to diverge and not converge. What the brain knows

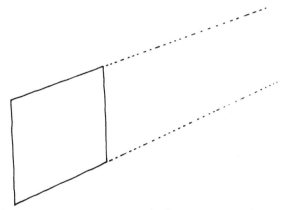

4 *Two edges converging*

and the eye observes seems to be ignored and a third state is drawn by the hand (Fig. 5). Fig. 6 shows what should have been drawn.

Does this degree of accuracy matter? Well, drawing is a communication, and understanding shapes and signs is part of everyday life. To the artist, perspective is part of the vocabulary of his art; to be understood—and used or discarded by choice. I must emphasise that I do not advocate that good art is only that which obeys the facts of perspective. But freedom of choice in art comes from knowledge, and perspective is part of that knowledge.

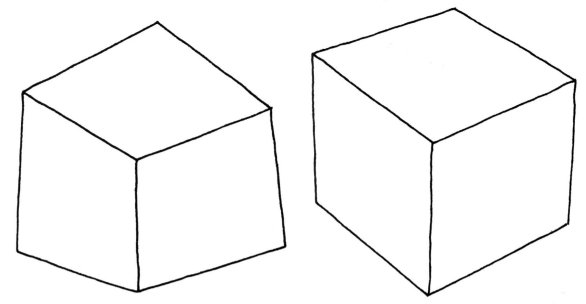

5 *Edges diverging* **6** *Cube correctly drawn*

7 *Scotney Castle showing the use of perspective and many of the aspects described in the following chapters*

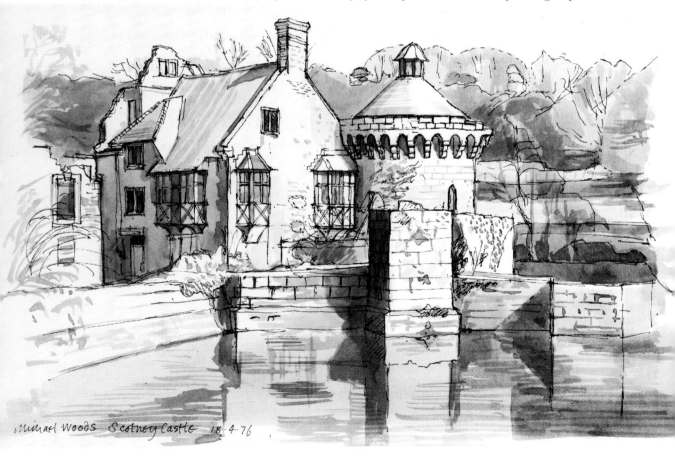

Michael Woods Scotney Castle 18·4·76

1 Setting up

In order to make all the right judgements as a drawing progresses, the artist must set up in the right way. The sketch pad or drawing board may be supported on the knee, but held up (Fig. 8), or supported on an easel in that position (Fig. 9). Whatever the solution, what is horizon-

8 *A drawing board held in the most satisfactory way on the knee*

tal in the subject must be drawn horizontally on the paper and what is vertical in the subject, vertical on paper. The reason for this is that, as the drawing develops, lines at various angles may occur, and the only way to judge their correct tilt is to relate them to a basic absolute, i.e. the horizontal or vertical, and the edges of the rectangular paper will provide these in the most immediate way.

The artist should view the subject directly

9 *A drawing board supported on a light sketching easel, allowing a view of the object over its top*

ahead, while the surface on which the picture is being drawn should be either directly below his or her view, or immediately to the right or left of it (Fig. 10). To try to remember an angle, to have to turn to one side, to work obliquely, can spell disaster for accuracy (Fig. 11).

A friend of mine once confided that at school she had been told to hold up a pencil and directed to waggle it around. Years later she still had no idea what she was supposed to have gained by so doing! Firstly, by stretching the arm out full length away from the eye—in order that this distance is kept constant (Fig. 12)—and towards the subject being observed, the pencil can be used as a straight edge to clarify the vertical or horizontal, or to assess the angle of a line in the subject either by following its angle (Fig.

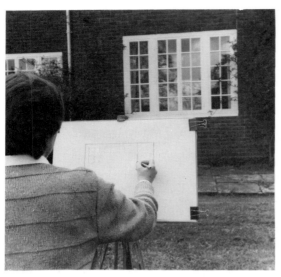

10 *The object, in this case a window, drawing board and artist. Note how the top of the drawing board makes a useful horizontal*

11 *A bad drawing position, where nothing will help the judgement of vertical and horizontal*

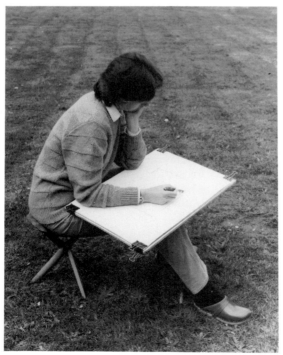

12 *The arm at full stretch and the pencil being used as a straight edge or a measure. It is crucial that the distance from eye to pencil is kept constant, otherwise accuracy will be affected*

13), or by comparing it with the vertical or horizontal pencil.

The second way in which the pencil can serve is to judge the comparative size of two or more parts of an object. To do this, the pencil is held at the sharpened end and, using one eye to look, the free end of the pencil is lined up with one point of the subject which is under observation. The top of the thumb of the hand holding the pencil is positioned to line up with the other end of the part being measured (Fig. 14). Holding this position, the pencil can then be moved to a second part and a comparative judgement made (Fig. 15).

Thus, the artist must first be an observer; picking the spot from which to work, checking horizontal and vertical, and able, with the use of a pencil, to make comparisons of the parts of the subject being viewed.

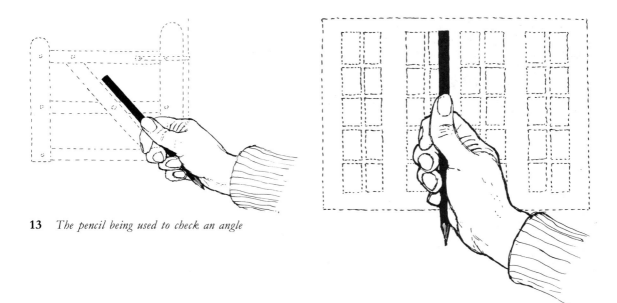

13 *The pencil being used to check an angle*

14 *The pencil being used to make a vertical measurement*

15 *The pencil being used to make a comparative horizontal measurement which is the same as that made in Fig. 14*

2 Basic principles

Figure 16 shows a rectangle enclosing two diagonal lines with patches between them. If one is told that the rectangle is a window, then one moves on to the fact that the diagonal lines belong to something beyond it. The identification can then be made that it is a giraffe walking past a window, but only part of its neck is seen! There are many such comic drawings which, for their correct interpretation, depend on knowing some absolute.

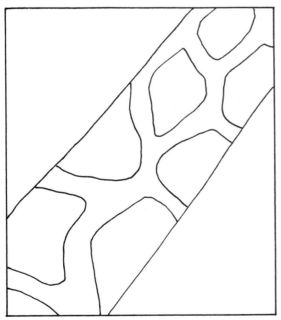

16 *Giraffe walking past a window*

This idea of a window is a useful one. The glass of the window and the picture can be thought of as the same thing. This is the picture plane. Anyone can begin to explore the rewards of drawing by trying it on glass. From a window (possibly upstairs because the shapes will probably be clearer to see) select a view of a simple building, shed or greenhouse nearby (Fig. 17). With a fibre-tip pen containing a water-based ink in your hand, shut one eye, and with the other observe the building through the glass of the window, and, following the lines of the structure, draw them on the glass. You will have to keep very still, for any forward or backward or

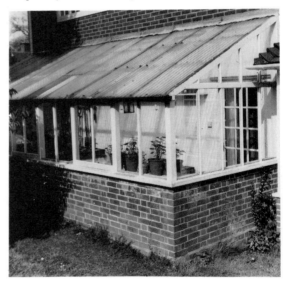

17 *A view of a greenhouse providing an excellent subject for drawing on glass, because of its clear, angled construction*

sideways movement will of course change your view and make a wobbly drawing. But even if it is not accurate, you will find that the result will look reasonably convincing. A damp rag will

soon remove the marks. An old picture frame with its glass (but with the picture and mount removed) will perform a similar role, or even a piece of clear acrylic sheet. But to find how these lines come to be at such angles, you need to start a traditional drawing on paper.

First of all the artist needs to be conscious of what is vertical, what is horizontal and what is straight ahead.

There are some almost universal images which, for this purpose, are classic. Imagine a railway running across a perfectly flat desert. Standing in, and looking at, this imaginary desert, your horizon will be straight ahead. If you stand in the middle of the railway track the two metal lines will appear to converge into the distance (Fig. 18). There are a few rules which can help the artist and the railway line presents

18 *Railway lines converging across an infinitely flat desert*

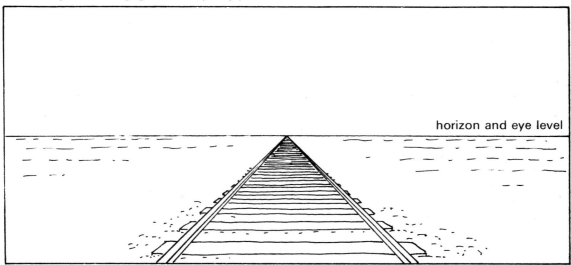

horizon and eye level

19 *Posts diminishing to the horizon*

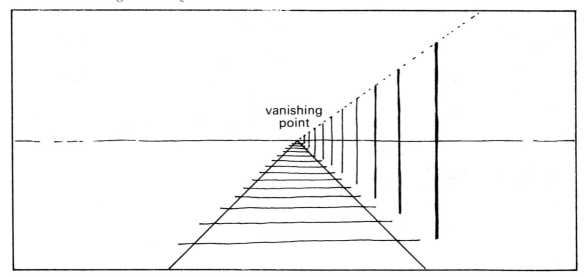

vanishing
point

the first. *Parallel lines will appear to meet at the horizon.* Now really it is known that railway lines are laid parallel—the lines only appear to converge. The sleepers on which the lines are fixed can be expected to be evenly spaced, but the further they are from the observer, the closer together they will appear.

As the observer is standing on the track, it will be below the eye; the eye level is the same as the horizon. The second rule is that *if the lines observed are below the eye level, they will appear to rise to the horizon as they travel away from the observer.*

Another element is added to the scene—posts—which are all of the same height, and spaced equally and parallel to the railway lines. Their tops will be found to create another line but this time it will descend to the horizon and apparently meet the railway lines at the horizon. This gives an example of the third rule—that

lines travelling away from the observer from above eye level will descend to the horizon (Fig. 19).

The point on the horizon to which parallel lines appear to converge and where they finally meet is called a vanishing point.

One possible criticism of perspective is that it may make a picture very stiff and over regular. Of course when working theoretically this aspect is emphasised, but one must remember that the underlying way of thinking is being presented. When the artist is out in the countryside lots of subtle variations occur. This can be seen in the drawing of a field (Fig. 20).

Returning to the desert railway and posts, the line joining the tops of the posts and ending at the horizon might, in real life, be a telephone or power cable (Fig. 21). This will not produce a rigidly straight line but one made up of curves as the wire sags from one post to the next. Later

20 *Irregular field furrows diminishing into the distance. Note that the actual horizon will lie higher in the picture than the actual end of the field*

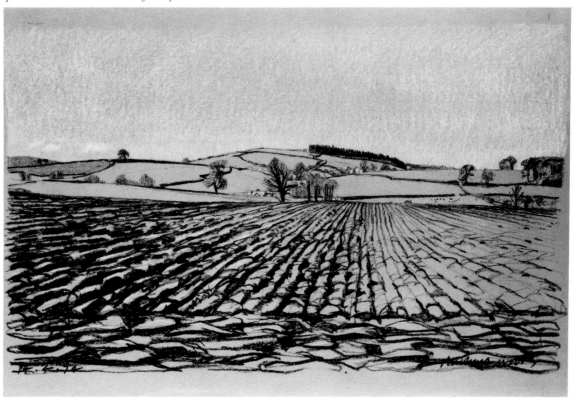

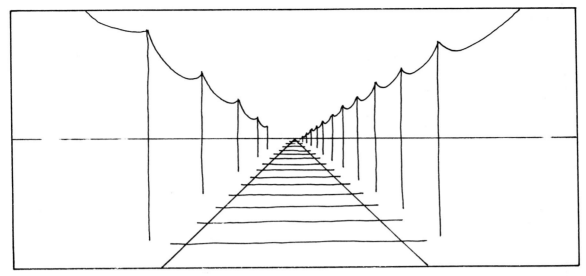

21 *Posts with wires still showing the priority of the tops descending to the horizon*

I will describe how to tackle curves, but what is important is that the characteristic of the tops of the poles runs in a straight, descending line to the horizon; the curve of the wire between two poles is a development.

Visualising a set of objects in a setting will be easier if everything is kept as simple as possible at the beginning. The land is absolutely flat, no hills or valleys; the objects are straight and regular. So, bearing this in mind, imagine a new

desert landscape, this time with a very simple building in the centre of the view. The building will be a cube. All the sides will have been made the same length. All the sides are at right angles to each other.

In the first view of it, flat-on and looking at one side, nothing will be seen of the other sides (Fig. 22). But if one moves to a position where two sides can be seen equally, then what is known to be a square will not be drawn as such (Fig. 23).

On the left hand side the ground line will rise and the top edge will descend to the left, travelling away from the observer. Think of these lines as continuing. They will finally meet at

22 *Basic building seen flat on*

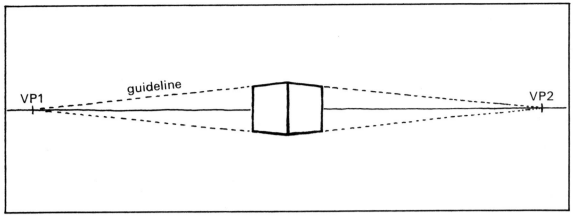

23 *Building seen from one corner*

their vanishing point on the horizon (VP1). These imaginary lines can be described as guide lines. When considering the railway lines it was the actual object which continued to the horizon, but the building is compact. In order to help the artist in its construction the guide lines can be drawn through to the vanishing point. They should be drawn faintly but, when experience has been gained, they need only be visualised—

considered but not drawn—except where they are used to form the actual building.

From this same view point the right hand side of the building will be similar, but these two lines will meet at their own vanishing point on the right (VP2).

If the view point is changed and moved further to the right, the amount seen of the right hand wall will increase, its vanishing point

24 *View moving to the right*

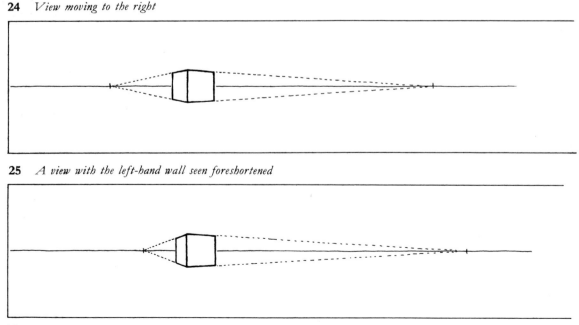

25 *A view with the left-hand wall seen foreshortened*

moving yet further to the right (Fig. 24). While this is happening less will be seen of the left hand wall. As less is seen (Fig. 25), the wall's vanishing point will move in nearer to the building, and the top line and ground line of the wall will become steeper in angle. This wall can now be described as foreshortened. It is a loose term but helpful to describe an extreme view of an object reduced in its apparent size by the effect of perspective.

The theory can be turned to practice by drawing a simple, isolated, flat-roofed building, or even a cardboard box on a table. Just concentrate on the edges, anything else will only confuse at this stage.

Up to now a mid-height view has been taken, but two more situations must be added to complete the possibilities of relationship (for it now will have become apparent that drawing is not just about the object, but about the artist related to the object).

Imagine a new place for the artist, in a ditch, with eyes just level with the ground. The ground line of the house will then just about coincide with the horizon, while the top edges of the walls will have steeper angles dropping to VP1 and VP2 (Fig. 26).

regular shape, the two far top edges now revealed will have the same vanishing points as the edges to which they are parallel (Fig. 27).

In these drawings the object has been drawn quite small in relationship to the whole picture, enabling the vanishing points to appear within its boundaries (Fig. 28). Fig. 29 shows how a subject is more likely to be drawn with the vanishing points outside the picture boundary.

So far I have described a land of deserts and cube houses, but not all objects are cubes. Most boxes will be regular but not have sides of the same length. So when drawing be aware of this and be prepared to measure and judge what you see.

Here are a few suggestions which may help you to do this. Look at the height of the box in Fig. 30. Consider how many times it goes into the length of the longest side on the left. In this particular example it goes twice. The width seen of the foreshortened side is half the height. Similar comparisons may help your drawing. Of course you can find that a box made with a long side and a short side can be viewed so that the short side actually appears to be bigger than the long side, which is strongly foreshortened (Fig. 31).

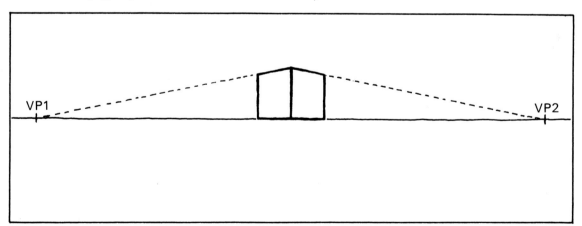

26 *View from ground level*

Taking off in a helicopter, the artist now rises above the house and hovers. His or her horizon is straight ahead and is now totally above the house. But something new has happened. The top of the cube has appeared and, because of its

In a house many items present themselves as objects involving simple perspective. Tables, chairs, cookers, beds, refrigerators, television sets—all are likely to have basic directions which give good opportunity for drawing practice, but

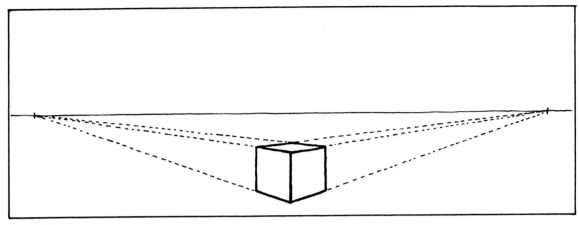

27 *View from above*

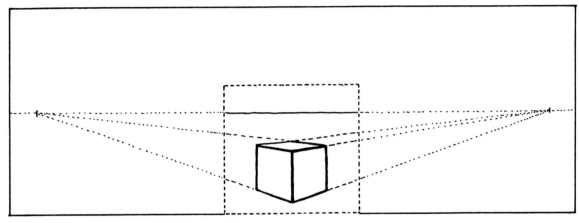

28 *Drawing showing likely area to be considered*

29 *(Right) Drawing without vanishing points*

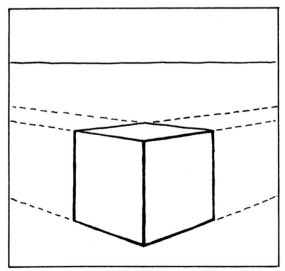

18

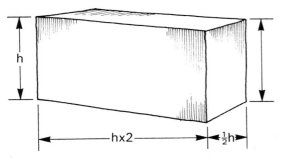

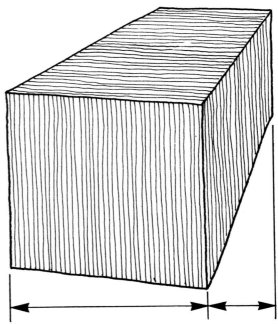

30 *Drawing of a box showing the comparative size measurements*

31 *(Right) The long side of the box appearing shorter than the short side*

32 *A railway carriage showing how its length is actually drawn to a dimension smaller than its width*

you must be careful not to allow the function of the object to cloud your awareness of the basic structural lines.

When the subject is quite close by, the angle of a line which is very nearly horizontal is difficult to judge. It may be helpful to think of the rules. Decide which end of the line is furthest away. If it is below your eye level it will slightly rise as it recedes. If it is above, it will slightly descend. If there is more than one regular object in view, they may well not be parallel to one another. Because of this, the three buildings or

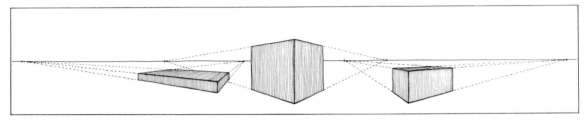

33 *Three boxes each having its own vanishing points*

34 *An apple box showing how the furthest half appears slightly smaller than the nearest half*

boxes in Fig. 33 will each have its own set of vanishing points. Guide lines are useful here, but inevitably they will overlap and should be kept faint so as not to confuse.

Some things are divided by an obvious middle part in the centre of one side. Take for example a wooden apple box banded with wire at each end and a third band about its middle. In this connection 'half way' has a special significance. One will understand that the distance from each end to the middle band will have been made equal. But when viewed from one corner as in Fig. 34 the second 'half' will be slightly smaller than the first 'half'. It is in a way a development of the railway line and the poles standing beside the track. *If three elements are in actual fact equally spaced, when seen receding, the gap between the second and third element will appear measurably less than between the first and second.* This relationship of parts will crop up again and again.

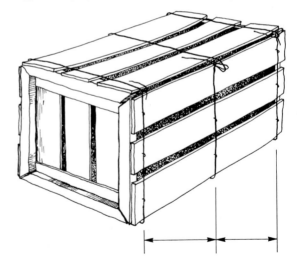

③ People as a measure

The fact that people are roughly the same height gives the observer of a scene a clue to the size of all the surrounding objects.

If one takes the average height to be 1.65 metres ($5\frac{1}{2}$ feet), then it is not too difficult to judge the height of double that, i.e. 3.3 metres (11 feet), or three times a person, or four. People in a street scene or a landscape help to define space, because they will act as a comparative measure. Some vast buildings do not necessarily look huge until compared with a figure (Fig. 35).

I recall a cartoon film which was about very small creatures like ants and spiders. The scene showed insects walking along a road between banks. Only when an enormous foot came across the top did one realise that the 'road' was in fact a crack in a pavement and the foot, normal human size.

The artist with a lot of experience will draw or paint with confidence, for his or her eye will quickly assess and compare proportions and sizes. Artists with less experience will find it useful to practise comparing parts and sizes, and the figure is a help in this way. Of course, no one element in art will produce a sudden miraculous improvement, but there are some ways of thinking which may help drawing to develop. The proportion of buildings is directly related to figures.

The desert cube house (Fig. 36) does look very bare, yet quite quickly a few additions will improve its appearance. A door and five windows (Fig. 37). The sides of each will be drawn vertical. Notice how wrong it looks (Fig. 38) when they are not. The tops and bottoms of the rectangles will aim at the same vanishing

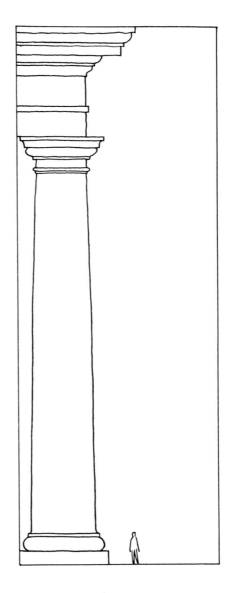

35 *Size of pillar clarified when seen with a figure*

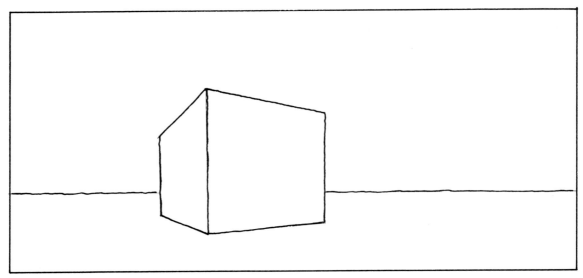

36 *Basic cube for the house*

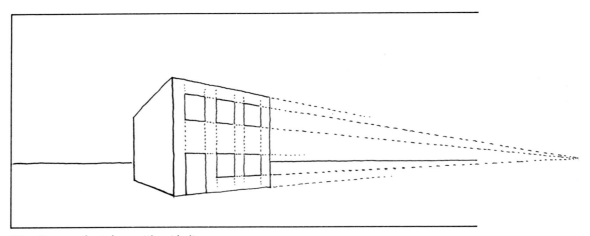

37 *Doors and windows with guide lines*

point as that of the wall in which they are situated. There is often a temptation to consider each window separately, but more often than not they will lie directly above one another and in line with one another, so guide lines will help place their position correctly.

The roof comes next (Fig. 39). Its ridge will be parallel to the wall below, so will aim at the same vanishing point (VP1), but the gable end needs care. Assuming that the building is still regular, then the apex will come half way along the end wall. But as I have said before, the

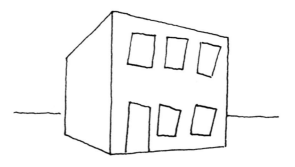

38 *Doors and windows poorly drawn*

22

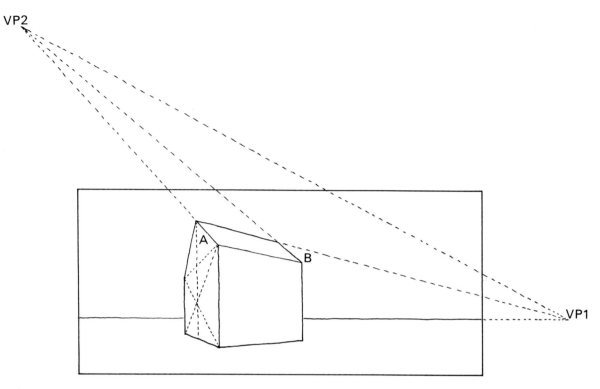

39 *Intersecting diagonals defining the ridge position and the vanishing points of the roof*

40 *House with poorly drawn, diverging roof edges*

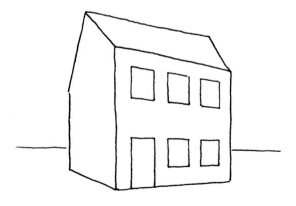

second, furthest 'half' will be slightly smaller than the first. This halving can be assisted by drawing the two diagonals within the side wall as seen in Fig. 39. A vertical line through their crossing point will mark the half-way position and, when continued upwards to the ridge of the roof, will create the proportions needed.

The slope of the roof presents the first oblique surface to be considered. In fact, of course, it follows the same system as the walls of the house when receding, except this is receding into the sky. The near edge A and the far edge B will have been built parallel but, because they are travelling away from the observer, they will converge to their own vanishing point way up in the sky (VP2). If this slight convergence is omitted the roof will look uncomfortable (Fig. 40). The horizon of the roof plane is a line which joins VP1 and VP2 as shown in Fig. 39. Finally, a chimney will relate to both the main

house in its top and sides, and the roof at the point where roof and chimney meet (Fig. 41).

Re-consider the proportions by placing a figure at the front door (Fig. 42). Can it enter without bumping its head? Can it look out of the window on the ground floor? Where would

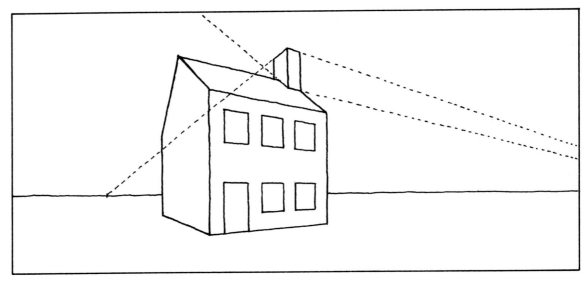

41 *Drawing showing construction of the chimney*

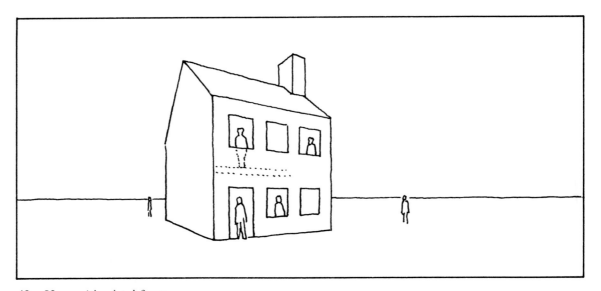

42 *House with related figures*

the ceiling be above its head? Add a bit for the thickness of the floor and would it be able to look out of the upstairs room? All may seem well until a comparison of this sort is made. So, when drawing a building, be it real or imagined, one should always keep its function in mind.

The house has now become more of a reality, and one dominating feature is likely to be the skyline. This is often confused with the horizon. Looking out to sea they will indeed be the same, but on land there may be hills in the distance. The skyline is where the sky and land meet. The

24

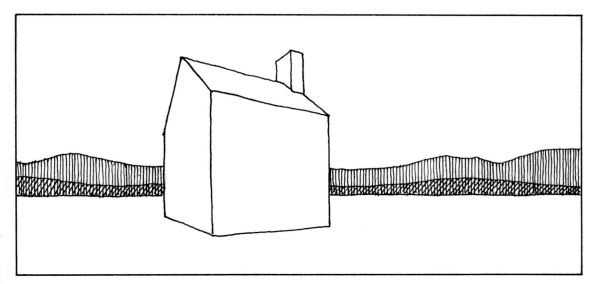

43 *Hills passing behind house*

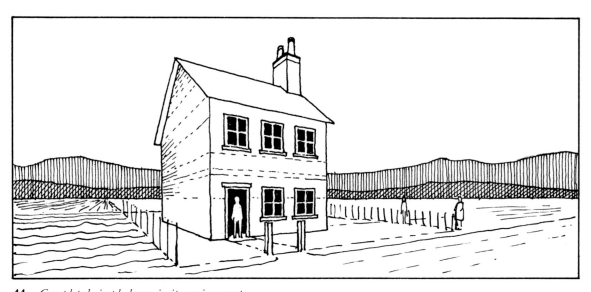

44 *Completed simple house in its environment*

actual horizon will lie below this, and the vanishing points will lie on the horizon and not on the skyline.

The appearance of the imaginary flat landscape can be improved by adding some hills (Fig. 43). These will help the house to stand out as the hills will pass behind it. A few lines for the garden boundary and some lines of furrows will turn what started out as a theoretical cube into a house in a landscape, even if still quite simple (Fig. 44).

At this stage, if you practise drawing from

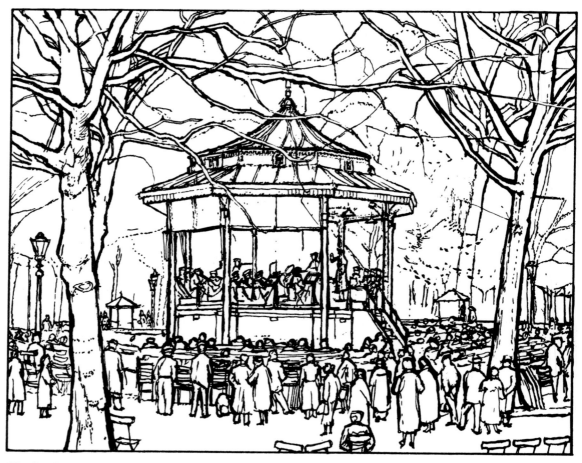

45 *Band stand, Hyde Park, London drawn in 1955.*
Note how the figures give scale

common objects in the home, try to avoid over-complicated constructions. Avoid lettering or patterns on objects, and concentrate on the overall direction of lines, the relative proportion of parts, and the simple sub-division of any parts.

4 Changing levels

The surroundings of ancient castles are marvellous places for children to play—hiding in hollows, running round the tops of defence mounds, and charging down ramps. For the artist, the site can be equally exciting, for changes of level can provide many visual surprises.

When considering any change of level, it is best to start with the conception of a flat area. Any bumps or hollows are then understood more clearly as changes against that absolute.

Fig. 46 shows a flat, raised platform. It follows all the principles covered so far. Against the nearest corner a ramp has been drawn (Fig. 47), its top edge coinciding with the edge of the platform. Its bottom edge vanishes to VP2. Its two rising side edges have their own vanishing point above VP1, at VP3.

On top of the first raised platform a second platform has been constructed (Fig. 48), the vertical lines being the same height as for the first, but this second platform covers only half of the first. Against this, a second ramp has been drawn; its bottom edge and its top edge use

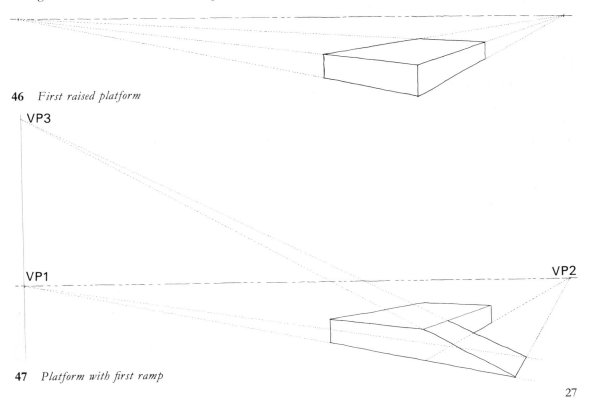

46 *First raised platform*

VP3

VP1

VP2

47 *Platform with first ramp*

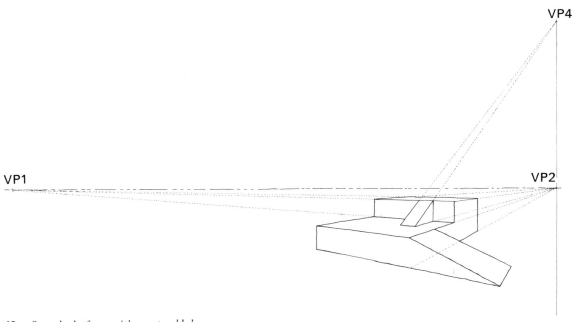

48 *Second platform with ramp added*

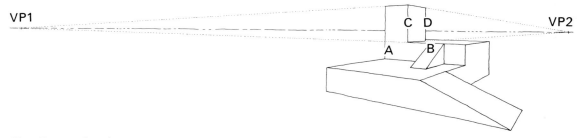

49 *Construction of tower*

VP1 while the two sides sloping upwards have their own vanishing point vertically above VP2, at VP4.

The construction of a tower at the left hand side of the second level is next (Fig. 49). Its height is equal to the two platforms already constructed. The vertical A is continued upwards and, using A as a measurement, the line above it is made twice that dimension. A guide line is drawn from VP1 to the top of the extension of A, and the line is continued to the right. Approximately half-way between A and B a vertical, C, is drawn, and this becomes the nearest corner of the tower. The top of C is then con-

nected to VP2, and another vertical line to make the right hand side of the tower, D, is drawn in such a position that the distance between C and D is a little less than that between the verticals A and C. A simple castle has now evolved.

By adding people, scale can be given to the whole structure, showing how their size and the size of the building are directly linked (Fig. 50).

If a person is drawn standing at each corner of the first platform and if they are made the same height as the platform, immediately it will be obvious that the height of either the first or second platform, at any given place, will also define the height of a person standing there. By

28

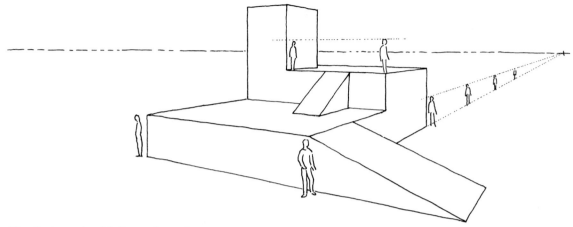

50 *Basic castle with figures for scale*

the tower, a person only comes half-way up the wall because it has been drawn twice the platform height. As the structure of the building diminishes to the horizon, so too does the size of a person. If a person is drawn at any point, it will be found that, by drawing a guide line from the top of the person's head and another from the feet to any vanishing point on the horizon,

the height of any other figure will lie between these two lines.

If a figure is to be drawn standing half-way up a ramp on the castle (Fig. 51), start at a known height, point AB, which is both the height of the platform and the height of a person. Point CD is half-way across the width of the ramp and by comparison with AB will be

51 *Locating figure on ramp*

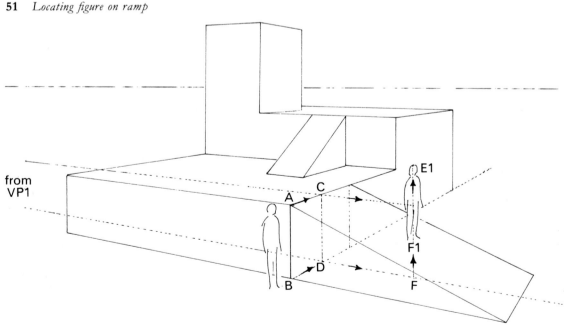

from VP1

slightly smaller as it is contained between the lines vanishing towards VP2. EF is an extension of CD from VP1.

To recap, the person, AB, has moved away to CD and now moves forward to EF. But, because the feet of the person at F are to stand on the ramp, the person will have to be raised vertically from F to F1, the head rising from E to E1.

Sometimes part of a person may be hidden because of the low angle of the viewing eye. A person on the top far side of the castle tower would be just such a case. To draw a person in this position, guide lines are particularly helpful, for one needs to visualise the far side edge of the tower. When this far edge is established, it is possible to move a person from the left corner, which can be seen, to the furthest corner, which cannot. Only the upper part of this figure will be seen, the lower part of the legs being obscured by the nearest corner of the tower (Fig. 52).

to draw stairs one has to use two vanishing points on the same side. VP1 will control the directions of the main ground area of the stairs and all subsequent steps upwards. VP2, directly above VP1, will control the overall upward direction made by the risers, while VP3 will control all the diminishing elements running, in this diagram, to the right, such as the nose of each step. A vertical, running through the edge of one riser, can be used as a measure to enable all the steps to be drawn as if made the same size. It will be noticed that those steps which lie to the right of the dotted vertical line in Fig. 54 get progressively larger as they come forward, and those which lie to the left of it, progressively smaller. When trying a drawing of this complexity, draw it as large as possible for the subtle changes in angle in each step will be more easily seen.

One of the problems about drawing stairs in

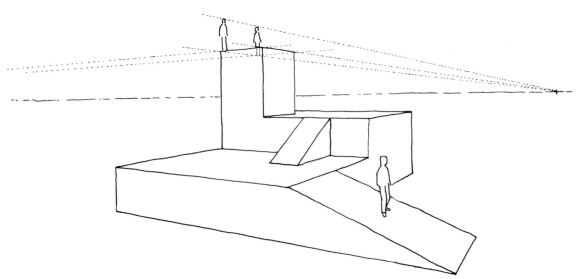

52 *A figure partly hidden from view*

There is a close connection between a ramp and stairs. With many pedestrian subways one has a choice. With both, the movement is upwards (or downwards) and the direction of movement follows that of the ramp. But stairs gain the upward movement by a series of horizontal stages (Fig. 54). I put it like this because

many houses is that one is not able to obtain a view from sufficiently far away. But, if you do attempt this, take only part of the structure, for otherwise there will be a temptation to move your head, enabling you to look from the foot of the stairs to the top, and thus you will be trying to draw from more than one view point.

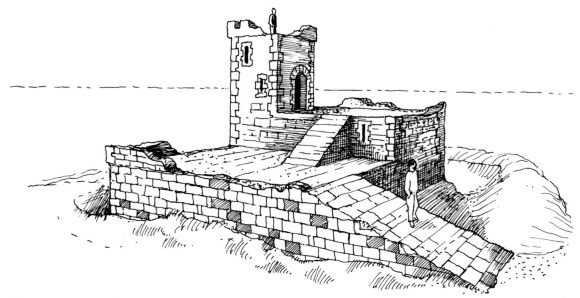

53 *Completed castle*

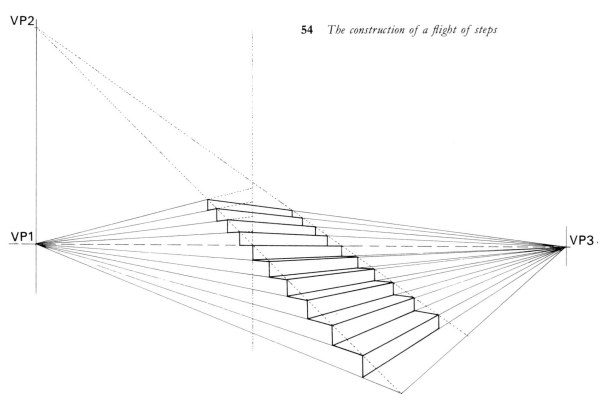

VP2

54 *The construction of a flight of steps*

VP1

VP3

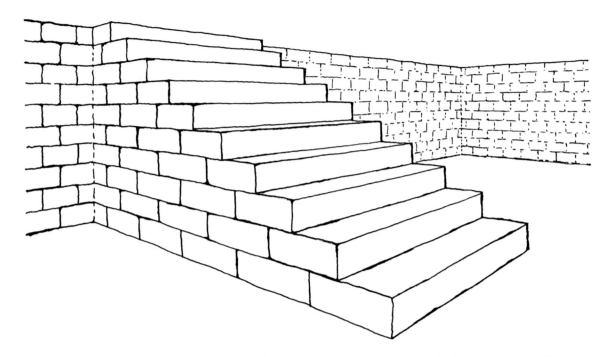

Steps in gardens are much more likely to provide the economy of number and view and, in the beautiful gardens of great houses, one can often see fine stonework in the surrounding structure. These courses—in brick as well—can help the artist to judge angles and establish the horizontal; don't just think of them as detail to be filled in later. I have seen many basically good drawings of buildings spoilt by haphazard brickwork (Fig. 55).

Remember that many building elements are of standard sizes, and this is not a new notion, for standard measurements have existed for centuries.

Not everything, however, is so precise. The ground itself can be very complex, with natural formations, erosions by water, terrace-like paths made by animals, the ploughing of fields, cultivation, man-made ditches and banks, producing formations which are so varied that the artist must look carefully to decide what is a constant factor within the picture. Many bumpy lines may conceal a basically straight direction; many swinging curves may be made up of several straight lines.

The analysis of pictures into blocks and lines

55 *The flight of steps developed with stonework*

56 *(Right) Steps at Castle Rising, Norfolk*

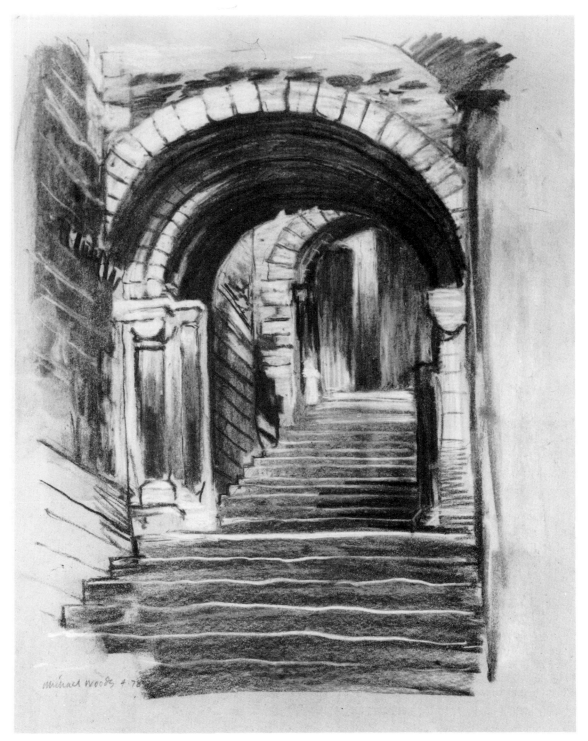

Michael Woods 4.78

33

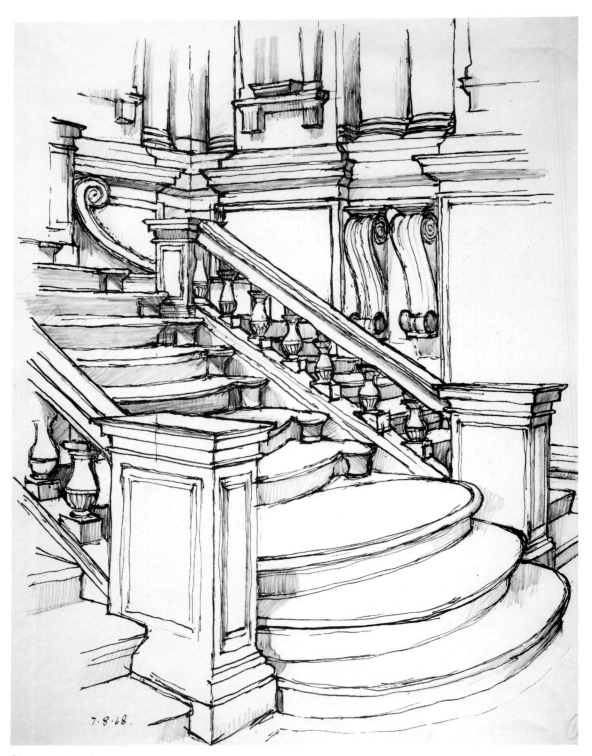

7.8.68.

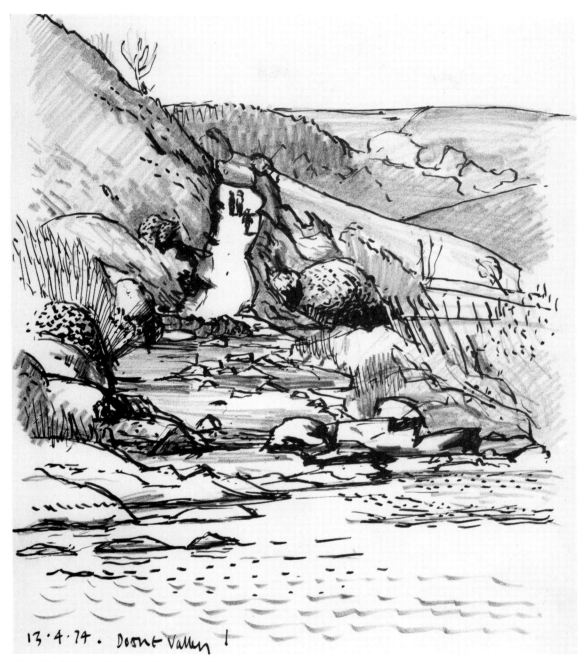

13·4·74· Doone Valley !

57 (Left) Steps in foyer of Lorentian Library, San Lorenzo, Florence, designed by Michelangelo

58 Doone Valley: a country path disguising a basically simple ramp

59 *A view from the South Downs, where many straight lines are concealed by a rolling landscape*

is not everyone's choice but, at the same time, many forms do have an underlying simple structure. The aim is not necessarily to change the form to its simple comparison, but simply for the artist to become aware of what may not at first be realised. Once the underlying form is realised, the artist is less likely to be distracted by minor variations.

It is in this area, the underlying directions and relationship between elements, that perspective plays its part. Its role is not to dominate with a mechanical frame, but to help the eye maintain its priorities.

5 The circle

The circle will perhaps first appear to the artist in the form of a flower pot or vase. Many student painters who are excited by blooms or foliage become distracted by the container and, instead of concentrating on the flowers, become involved with the task of drawing round pots in perspective. At first it is often difficult.

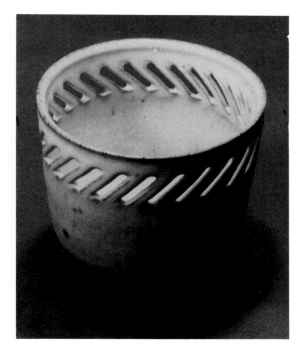

60 *Pot by the author showing its top seen as an ellipse*

Early attempts to get the shape right may well result in too big a curve coming to a point where it meets the sides. The ellipse actually seen may be surprisingly slim (Fig. 61). The use of measurement comparison between the width and

depth is essential, for it is possible to be wrong without realising it, and only this detached calculation will reveal the error. This measurement is not a method of drawing, merely a guide. If a rectangle having the observed width and depth dimensions is drawn, the ellipse will fit into it (Fig. 62).

61 *An ellipse*

62 *An ellipse constructed within measured dimensions*

63 *Circles seen obliquely do not come to a point*

The curve never comes to a point (Fig. 63), though at first glance it may seem to do so. It simply curves, increasing in degree as the ellipse nears vertical for the briefest moment before swinging smoothly away.

64 *The thickness of the material should be observed*

The fact that the material of the pot has a thickness can also serve the artist, for the double line, the outside and inside edges, can give extra interest and, when observed clearly, give considerable extra description to the material and character of the container (Fig. 64).

Nevertheless, the circle seen obliquely is difficult (Fig. 65). Another way of thinking about its form is to imagine the circle within a perspective framework. I have already dealt with the construction of a rectangle as part of a house. It is a fact that a circle lies within a square, touching the sides at four points (Fig. 66).

65 *Circle seen obliquely*
66 *Circle described in a square*

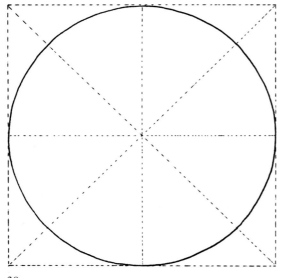

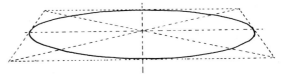

67 *The square drawn in perspective with the circle contained within*

If one visualises a square seen obliquely, the diagonals will make its centre; the centre of a circle lying within the square will have the same centre (Fig. 67). Using a clock face as a comparison, the points of the circle touching the square could be considered as 12, 3, 6 and 9. The diagonal divides the gap between 12 and 3 at 1.30, 3 and 6 at 4.30, 6 and 9 at 7.30 and 9 and 12 at 10.30. The final stage is to make the curve in a smooth ellipse between 12 and 3, 3 and 6, 6 and 9, and 9 and 12, as if one's pencil is following the tip of the hand round the clock face.

As drawings are made, special problems may arise; many can be solved by thoroughly understanding the construction of an object. I once acquired an old solid-fuel stove made of cast iron, and set it up with some other suitable objects for my pupils to draw. Draw they did, and yet problems arose with the hole in the top of the stove into which the fuel would be dropped. We were observing the object from some 3 metres (10 feet) away and the top of the stove was seen very obliquely. Attempts by me to help seemed only to confuse for I had to admit that what we observed did not seem right when it was drawn. In some frustration I walked over to the object and glared at this problem-making round hole. Only then did I realise it was not a round hole at all, but an oval one! Both I and my pupils had assumed that we were trying to draw a round hole in perspective and somehow our previous experience was making us try to see the shapes as suitable to that fact. The oval, presented to us with its widest dimension running left to right masked its true shape quite well and only when viewed and understood at close range did the shape become clear. With this new understanding and quite a few laughs at my foolishness, the faults in the drawings were soon corrected.

Knowledge is very important to the successful

drawing. To move round the subject, to view it from differing angles, can reveal a lot which might not have become apparent from the single view.

A tin of food can become a subject for drawing (Fig. 68). If a tall cylindrical can is chosen, all may be well until the curve of the top is compared with the curve at the base. If the

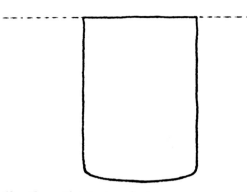

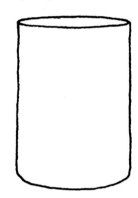

69 *Can with top at eye level*

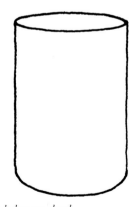

70 *Can with top slightly below eye level*

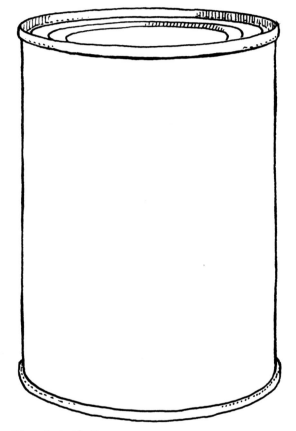

68 *A simple tin can*

top of the tin is on an exact level with your eyes, the top will appear as a straight horizontal line with no curve evident at all (Fig. 69). Without moving, look at the base, and it will be seen to be curved. If the can is lowered to below your eye level, the top ellipse will be very obvious while the base will be even more curved (Fig. 70). As the cylinder moves further below eye level, the ellipse will move towards being a full circle (Fig. 71), but it will not take this form

71 *Further below eye level*

until it is viewed from directly above and only the end is seen (Fig. 72). The reverse will be true for the cylinder above eye level (Fig. 73).

So, returning to the real subject and looking down at it on the table, remember that the curve of the base will be greater than the curve of the

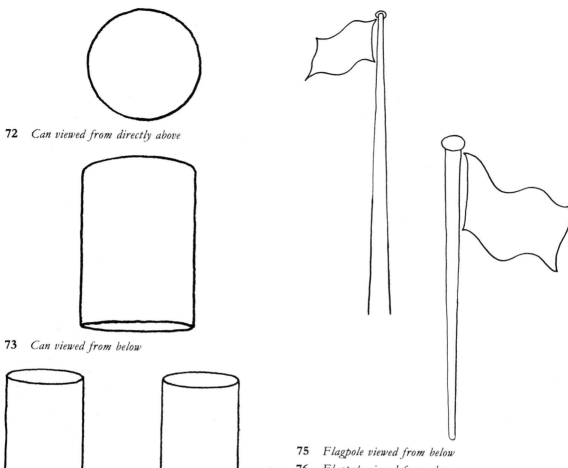

72 *Can viewed from directly above*

73 *Can viewed from below*

74 *The base curve should be more not less than the curve of the top edge when viewed from above*

✗ ✓

75 *Flagpole viewed from below*

76 *Flagpole viewed from above*

rim. At such close range, with a small object, the variation may be hard to see, but it is crucial to observe the difference (Fig. 74).

When considering all the regular objects up until now, all vertical straight lines in the subject have been drawn vertically. This is an acceptable solution only when the upward or downward view is not great. When looking at the can in a more extreme downward position, the sides will be found to converge to their vanishing point way below. Likewise, an upward view will have an upward convergence. So, when viewing a

very tall pole, for instance, from below, the lines will appear to converge towards the top as in Fig. 75. When viewed from above it will appear to diminish downwards as in Fig. 76.

Critics will differ as to the merit of paintings where there is conscious misdrawing. The following drawings show how information can be conveyed, the nature of its honesty being a matter of opinion. A mug has a round top (Fig. 77); it has straight sides (Fig. 78); it has a flat base on which to stand (Fig. 79); it has a handle (Fig. 80). One mug!

If one thinks of a bridge as half a hole, emphasis will be given to the air space beneath the bridge. By drawing the shape of this space one will accurately draw the characteristic shape of the arch.

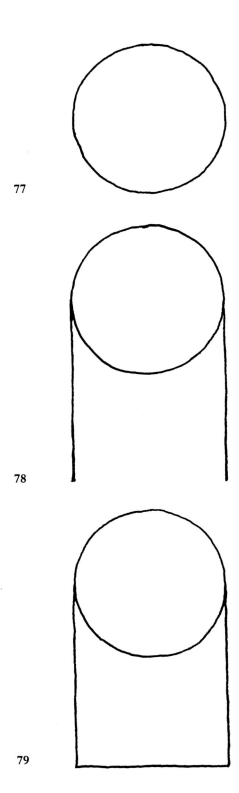

77

78

79

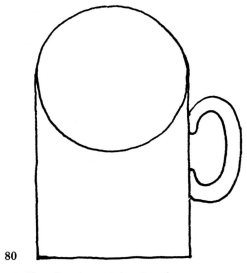

80

77–80 Conscious misdrawing of a mug

If one takes a semi-circular arch viewed obliquely, it can first be thought of in two measurements. The width and the height. The highest point of the arch must be decided (Fig. 81). If the form is reasonably regular, the first half will appear slightly larger than the second half. The two halves are likely to have elements which will be the same on both sides, so construction lines can help. Older bridges may have the main edge of the structure made of stone (Fig. 82). The edges of these wedge-shaped pieces, called voussoirs, will probably aim towards the middle of the semi-circle. The keystone may well be bigger and show the middle top point. The top of the bridge will clearly show its direction, but the lower line may have to be visualised if, for instance, it is masked by a bank. However, the ground line under the bridge will be very clear and take the eye through the arch to the far side. The curve of the far side of the bridge will echo the first side, and guide lines running to the left will help. It would not be unreasonable to complete the whole of the far side as a lightly drawn guide, for drawing a whole curve is easier than drawing a small segment (Fig. 81).

Once again, people can be used to give scale. In Figs 83 and 84 the same bridge can be made to look quite different in size.

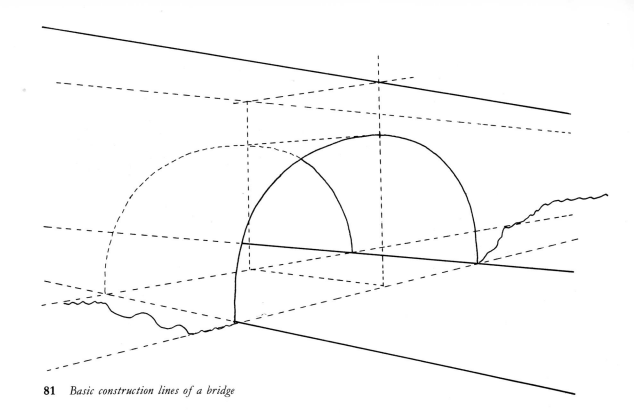

81 *Basic construction lines of a bridge*

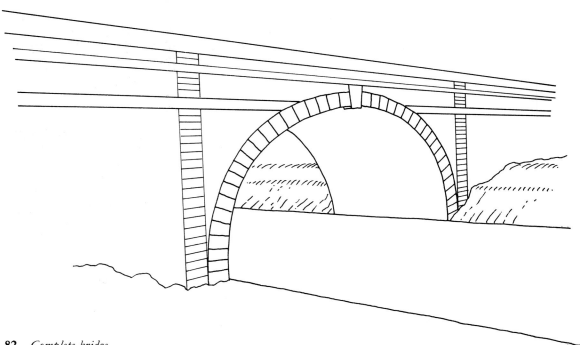

82 *Complete bridge*

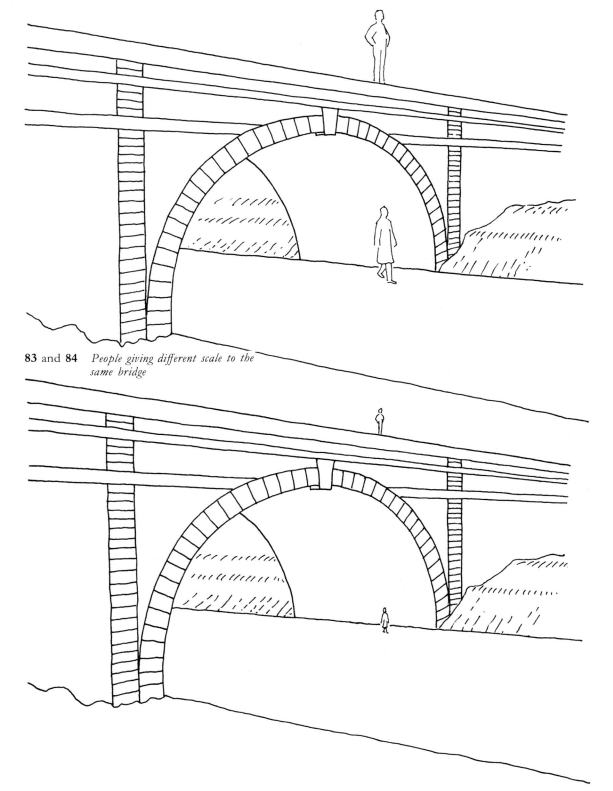

83 and **84** *People giving different scale to the same bridge*

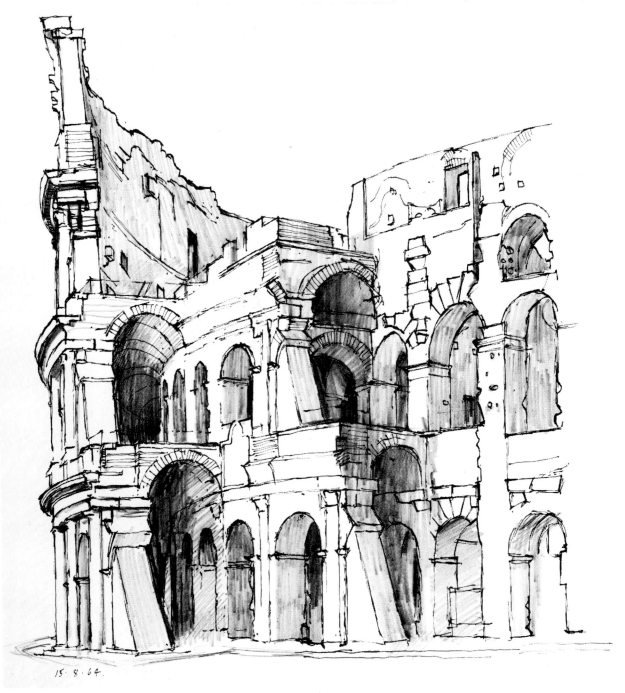

15.8.64.

85 *Colosseum, Rome: Arches are shown not only working in two directions but on a curve as well*

⑥ Shadows and structure

When one is confronted by lots of lines, their meaning can be obscure (Fig. 86). But, if shadows are added, a new clarity can be achieved (Fig. 87).

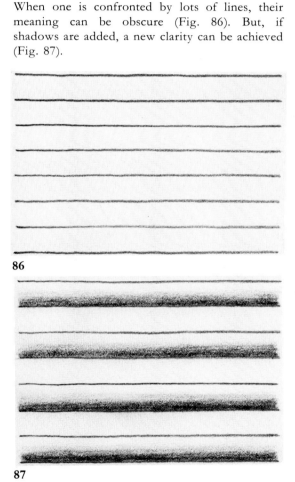

86

87

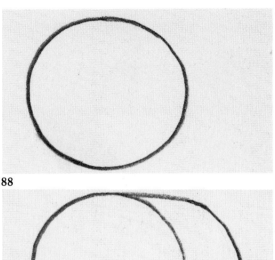

88

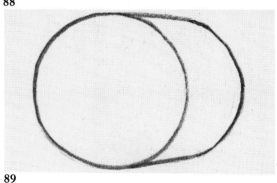

89

86–94 *Shadow used to clarify meaning*

A circle might be a number of things (Fig. 88). If a slightly side view is taken in order that a three-dimensional quality is obtained, it could be misinterpreted as describing a flat shape, like the track layout for a toy train (Fig. 89). The addition of shadows will clarify the interpretations (Fig. 90).

The addition of a cast shadow may make the object even more convincing (Fig. 91). Starting again with a circle exactly the same as in Fig. 88, the addition of a shadow will make it into a sphere (Fig. 92) and, with its cast shadow, show that it is lying on a flat surface (Fig. 93). If the shadow is drawn separately on the flat surface with a gap between it and the sphere, the image might describe a bouncing ball (Fig. 94).

45

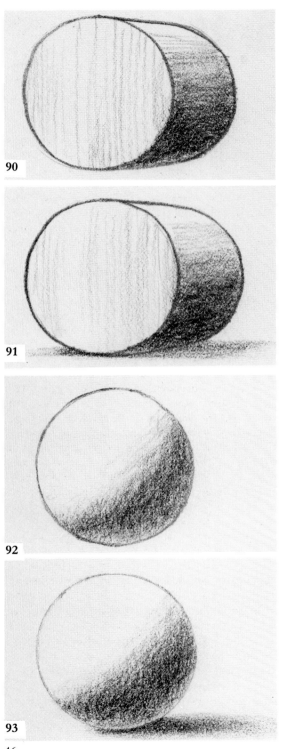

90

91

92

93

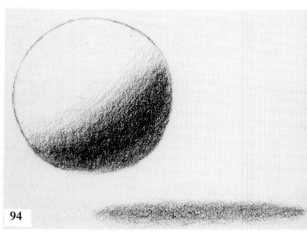

94

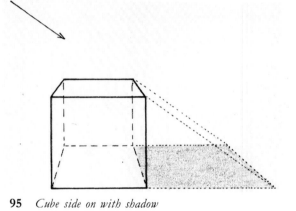

95 *Cube side on with shadow*

96 *Cube corner on with shadow*

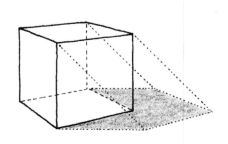

Rays of sunlight come from such a long distance that they can be assumed to be parallel. Guide lines to help work out the shape of shadows will follow the logic of regularly built objects or buildings. For instance, in Fig. 95, with the sun full on to the left side and quite high in the sky, the box will prevent direct light reaching the ground on the right side. This area of less light is the shadow. The furthest right boundary of the shadow will lie in normal perspective with the rest of the box edges. In Fig. 96 the box has been turned, but similar guide lines apply.

Sunlight reaching a sphere will be blanketed by the circle of its largest circumference. The circular 'tube' of shadow will produce an ellipse-shaped shadow on the ground because of the oblique angle, and will appear as an even slimmer ellipse because of perspective (Fig. 97).

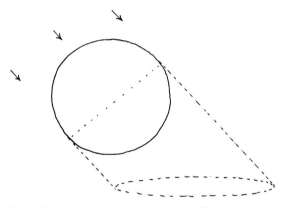

97 *Construction of shadow cast by ball*

In evening light the term 'shadows are lengthening' refers to this oblique angle becoming nearer to the horizontal as the sun drops lower in the sky. The angle of rays can become so low to the ground that a very small object can cast an enormously long shadow (Fig. 98).

If the source of light is man-made and small,

like a light bulb or torch, the edges of the shadow area are likely to diverge away from the source of light (Fig. 99). A classic example of this is the thriller film where a figure moves along a corridor outside an open bedroom door. The shadow is huge, the tension mounts, this is a giant killer about to strike. Wrong—it is a child holding a candle (Fig. 100).

Here again is a relationship. It is not simply a case of a light, an object and a shadow, but a relationship of relevant size and distance. Another factor concerning artificial light involves the filament and, in some cases, the reflecting surfaces. More than one light source can come from one light, so that frequently one gets a secondary shadow, less dark than the main shadow.

Torches and car head lights give a good example of this, where the beam centre has one intensity and the beam scatter a secondary one (Fig. 101). All too frequently less experienced artists make shadow edges far too harsh; in fact most are very diffused.

The artist needs to use discretion, but all the little elements which exist in an object can confirm and develop the atmosphere of the subject. Light plays a major role in this and the ridges, ledges, and folds either let the drawing down or provide a back-up to the main forms.

A window is an ideal object for consideration (Fig. 102). While it is easy to see the main framework, the thickness and shadow of the mullions must not be forgotten. The thickness of any object such as magazines, walls, parts of a chair, adds to the description of the subject.

Up until now I have assumed that the surface on which a shadow is falling has been flat, but shadows may fall across other objects and, by so doing, help to show their form (Fig. 103). The shadow in Fig. 104 suddenly changing direction leaves one in no doubt that the knife is sticking out over the edge of the table.

98 *Lengthening shadow*

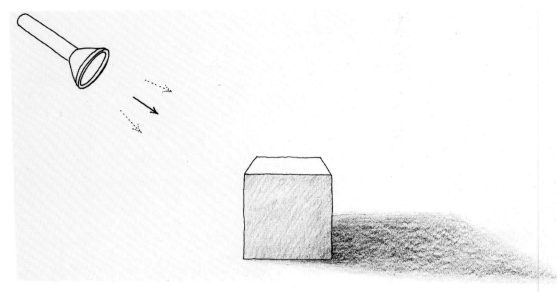

99 *Diverging shadow from artificial light*

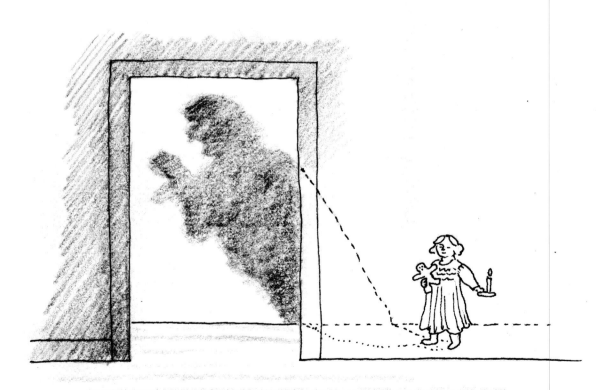

100 *Misleading, distorted shadow*

101 *Diffused edges of shadow from artificial light*

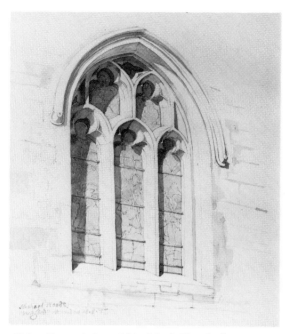

102　*East window of Blackford Church, Somerset*

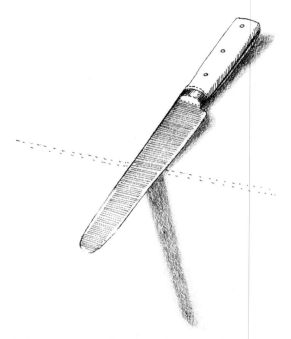

104　*Shadow revealing change in surface plane*

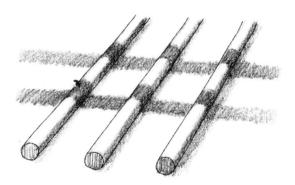

103　*Shadow falling across rods*

A favourite object for me is the daffodil. The bright, clear colour and its upright stance seem to herald the opening of the year. Indeed, the trumpet shape is appropriate. Yet, when being drawn, there can be a danger that the unity of the structure will go unnoticed. The 'follow-through' from the stem into the trumpet is vital, but because the petals block the way, the two sides may remain unconnected (Fig. 105). The use of shadow can help this enormously. When

viewed in the studio, strong directional daylight, or a more controllable spotlight, will assist in revealing this structure (Fig. 106).

Man-made objects are likely to show this aspect more readily. The gear and shaft from some machinery can be a fascinating subject for study. A pleasant enough drawing may look strangely unconvincing if one side of the shaft has no connection with the shaft on the other side of the gear wheel. It is not only an understanding of structure which is important but also of movement. Fig. 107 shows an object which rotates. Its rotation is linked to other parts by the teeth of the gear wheel. The shaft runs through the centre of the gear wheel and it is of a regular shape. Two wheels of a car are linked by a common structure and each part on one wheel will find its counterpart in the wheel further away. The lines of directions will follow through both wheels—tyres, rims, hub—and the shadow will help describe the height of the axle above the road surface (Fig. 108). One might imagine the wheels in a long packing case. Use the diagonals to find the middle of one end. The

50

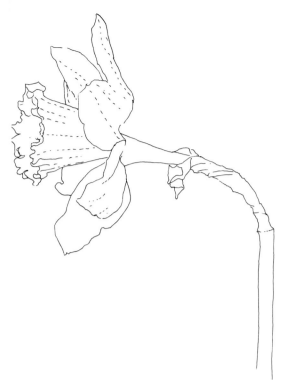

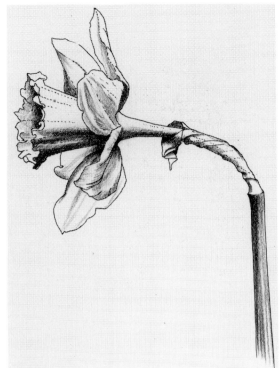

105 *Daffodil with weak structural relationships*

106 *Daffodil correctly drawn and with the helpful addition of shadow*

107 *Related gear wheels revealing structure through function*

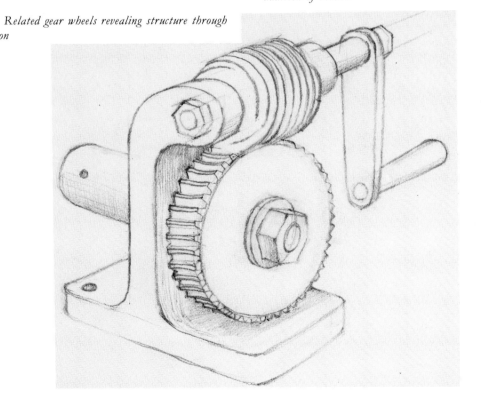

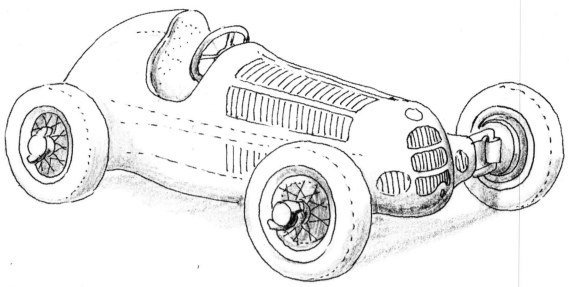

108 *A toy racing car*

long lines of the box and its contents will run towards the vanishing point to the right (Fig. 109).

Without the experience of drawing from real objects, imaginary drawing involving perspective can become distorted. Though the theory of perspective can be grasped, to use it successfully in a case such as this, experience will be needed to judge the relevant directions and distances which will look right. In both Figs 109 and 110 the theory is sound, but in the second the proportion is unsatisfactory. In Fig. 110 the vanishing point to the right has been placed too close to the object, producing an accentuated convergence. This has resulted in the wheel on that side looking far too small and too far away. In

109 *Related wheels in an imaginary packing case*

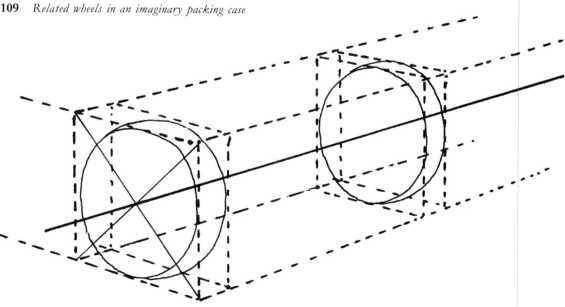

110 *An unsatisfactory packing case and wheels causing distortion*

most drawings it will not be possible to site both vanishing points on the piece of paper and in many neither will appear in the composition.

Though the example drawn here is a toy, car wheels are not everybody's ideal subject matter, but there is a surprising and valuable link with flowers. Cars turn by the pivoting of the wheel (Fig. 111). In this new situation the wheels take a new vanishing point of their own, separate to that of the main body. Flowers can show the same thing happening. The stem will thrust upward but the flower heads may be at various angles to it, so the directions involved with a whole cluster will be multiple, with each head creating a plane of its own, forming a sort of faceted dome (Fig. 112).

111 *Wheels turning which have separate vanishing points*

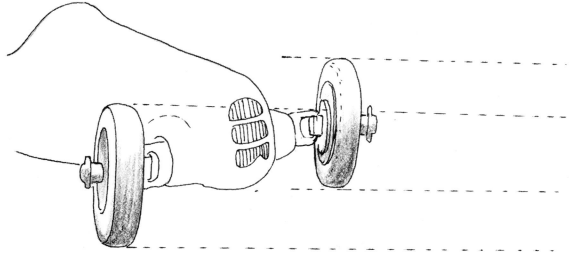

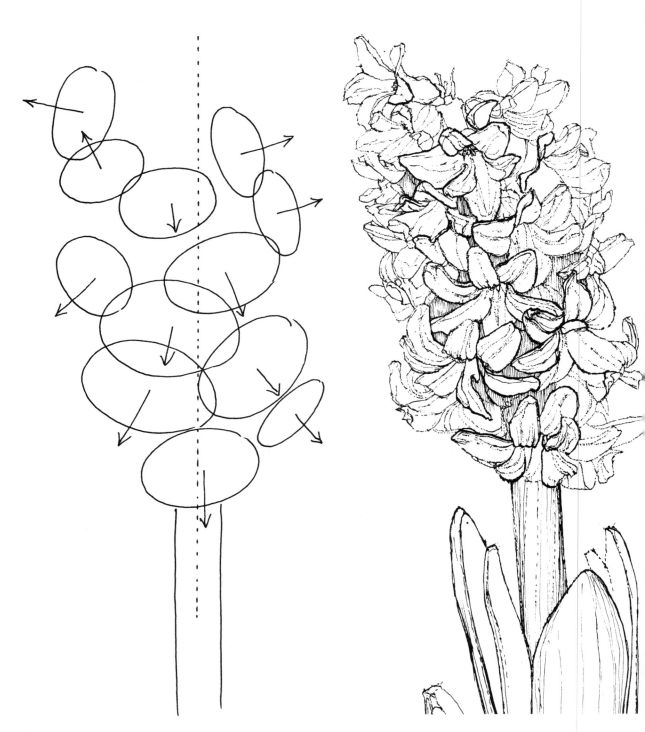

112 *Basic directions of a hyacinth head*

113 *Hyacinth*

54

There can be a situation where, because of the view selected, a picture is not successful. Though an object may have clear form and the perspective effect may have been judged precisely, the completed drawing fails to be understood by the observer of the picture. This can be a conscious intention of the artist. A lot of paintings with an abstract quality use this factor. The seemingly unreal having the strange conviction of truth. Truth and honesty are very important to any artist. This is a private honesty. Anyone trying to draw will know when a judgement has been fudged. Even when the work has some success there can well be a doubt about some aspect. If the chosen aim is to present some aspect of the visual world, then the roles of perspective and structure play a very important part. While lines alone may be adequate for some statements (Fig. 114), the addition of some areas of more light and some of less may help to define the hollows and raised areas. If the strongest light source is from one direction only, a logical sequence of light and shadow will be produced which, in turn, will describe the form.

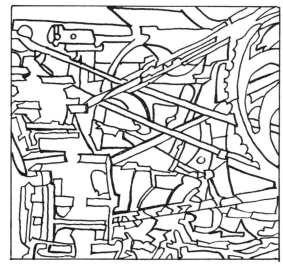

114 *Line drawing of part of a tractor which suggests abstract shapes and lacks clarity of meaning*

115 *Illustration of a Fordson Tractor, circa 1940, with dredging and hauling equipment; note how the use of shadow brings about a greater degree of understanding of the complicated mechanical forms*

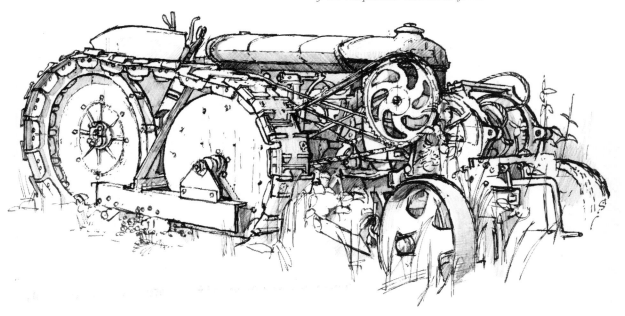

7 People and animals

Identification of a friend in one of those long school photographs is only possible by searching along rows of near identical figures and finding a familiar face. But figures seen moving can have particular characteristics by which firm identification can be made whether or not the face is seen. The figure may be thin or fat, short or tall; have an upright posture, or stoop. Since general characteristics apply to many thousands of people, it is only by a process of elimination that final identification becomes clear and positive.

When drawing the figure one tends to start off with the general notion. The nature of the figure is known—the sort of proportions: people are taller than they are wide, and have a certain number of limbs, two ears, one nose. But when drawing starts, a strange thing happens. All the words describing the figure do not necessarily apply. Here is a figure (Fig. 117). It has one arm, one leg and no eyes. The brain finds it difficult to accept this and formulae which may previously have been learnt will be employed. Parts like the top of the head, which are not normally thought to be of importance, are likely to be made smaller than they really are. Parts out of sight are likely to be drawn as if they can be

116 *School photograph*

117 (*Right*) *Drawing of a girl showing only some of her limbs*

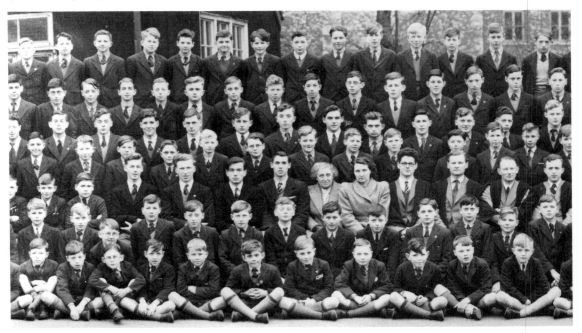

seen. The figure may be viewed from many different angles, and in itself is capable of many contortions. To understand the bone structure, and to know which bumps are muscle, will help. Likewise to know which parts are complete units and cannot bend, like the pelvis, and which can bend, like the spine. As drawing continues, the fascinating study of human anatomy will naturally develop. Indeed one will help the other (Fig. 118).

Perspective seen in the foreshortening of limbs, becomes most exciting when extreme views are taken. A figure lying on a flat surface, and drawn from the head end, will have a head which appears to be as wide as the legs are long (Fig. 119)! When viewed the other way round, the feet may be twice as big as the head (Fig. 120). As an arm bends, one part can completely disappear.

Guide lines, both vertical and horizontal, are very helpful. The figure has nothing which provides a basic line from which to start, so one or more can be added by the artist. It will then be possible to draw the shape of the figure by noting the changes of angle of the body against these absolutes. Backgrounds with vertical characteristics may serve in this way as well (Fig. 121).

Quite often the three-quarter view of a person provides the best chance for success. The side-on profile can be difficult because the recession across the chest can be very foreshortened (Fig. 122). However, the three-quarter view shows the nearest side and enough of the far side to suggest three dimensions. Care must be taken to prevent the parts on the far side being drawn bigger than they really are. Because the form is curved, the amount seen will diminish noticeably (Fig. 123). An ideal pose could be a person sitting in a simple, armed, upright chair. The chair, being of a regular form, can help give a sense of framework. The four legs of the chair will give a ground plan under the body, while parts of the chair can be used as a measure for parts of the body (Figs. 124 and 125).

However, it is the head which very often

118 *Whole skeleton*

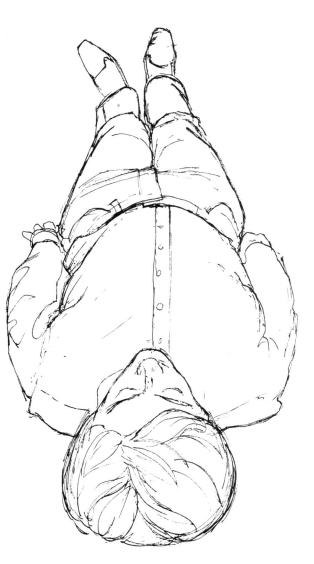

119 *The width of the head in this drawing will be found to equal the length of the legs, from waist to toe*

conveys the greatest quantity of information. What shades of meaning and reaction facial expression can give! It is, therefore, not surprising that for many artists the portrait holds a particular fascination.

120 *The foot on the right measures twice the width of the head*

121 *Verticals and horizontals are helpful comparisons to a figure*

122 *(Right) Old man—a profile view*

123 *(Opposite) Model's position showing the decrease in sizes of the far left side; note particularly the width of the cheeks and the width of the sleeves*

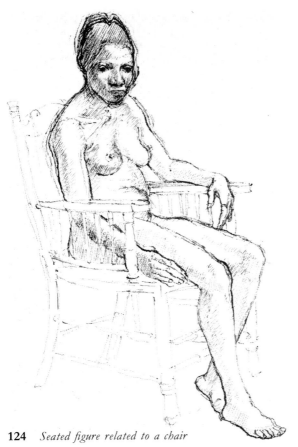

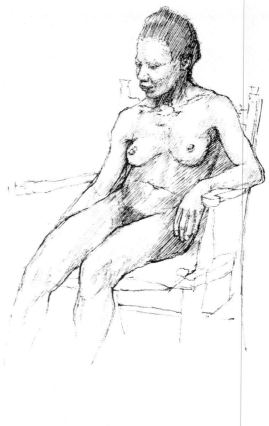

124 *Seated figure related to a chair*

125 *Second view of figure*

Is the head an egg? Yes and no. Yes, because as a very first thought it can be helpful. No, because if a formula is applied as rigidly as the shape of an egg suggests, the results can be dreadful. So if it is not to be an egg, how can the perspective of the head be explained? It is a complex structure and it will be helpful to understand some of the parts which are out of sight. The skull is supported on the spine and its point of pivot is at the back (Fig. 126). The front, which contains most of the main identifiable features, is not a flat mask; it is not a flat oval filled with things. According to the tilt of the head and one's view of it, the chin or nose or forehead may be the closest part. This must be established (Figs. 127, 128 and 129).

If measurements are taken, one will find that the same head viewed at different degrees of tilt, will create a different set of measurements for each position. Measure the topmost point of the head to the centre of the eye. Measure the centre of the eye to the chin. When looking straight at the sitter these two dimensions are likely to be similar (Fig. 130). If any fault occurs it is likely to be that of giving the upper part of the head too small a dimension. It is worth checking the measurements carefully for with students it can be an almost predictable error.

As for the whole figure, a three-quarter view is an ideal position from which to draw the head. There is little of the head which can be described as totally front or side, but the forehead does present a shape for which this could be a reasonable description. From the sides of the nose and below, the recession is quite marked and it is for this reason that very little of the far side of the cheek and jaw will be seen (Fig. 131). However, since the nose is frequently

62

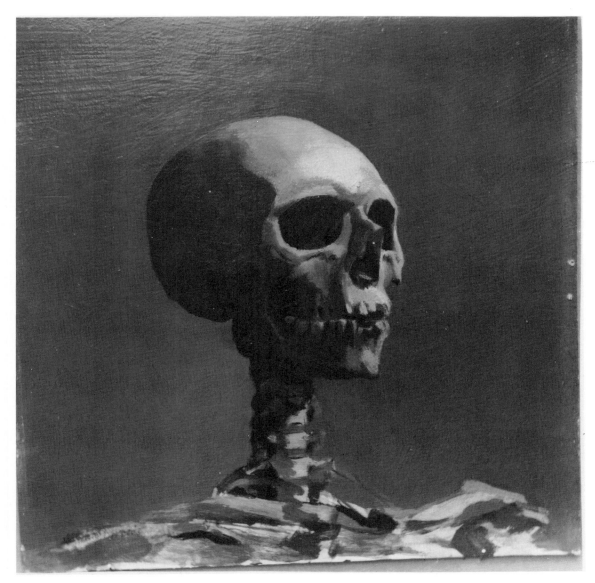

126 *Painting of a skull with supporting spine*

64

127 (Left) *A classic, near symmetrical view of a head*

128 *Head viewed from above*

129 *Head viewed from below*

130 *Head seen with top/eye, eye/chin dimensions near equal*

131 *Head viewed with little of the far cheek visible*

a plane, which will continue beyond the edge of the stone, and will most likely cross other planes, the direction of other cut surfaces. The planes on a head are important (Fig. 132). They are the walls of the shape, and any parts which lie there rely on the wall for their place and relationship to one another. One needs to consider, therefore, the plane of the forehead, the plane running away from the nose, the plane dropping away from the nostril area. Then in order to give some measurable boundaries, think of the forehead edge and the line of the jaw running into the line of the chin (Fig. 133).

The head is near regular, but not quite. Perspective creates a regularity which reveals that which is not. The use of perspective will help the artist create a three-dimensional framework, and there are extra elements which can give strong directional characteristics. Glasses give firm lines, beards softer edged planes, hats and neck lines give encircling shapes—all making a contribution. But the final likeness will only be

133 *Analytical drawing of the facets of a head*

132 (*Above*) *Stylised drawing where marks have been used to emphasise the basic planes*

described as being in the middle of the face, the inexperienced artist will be tempted to draw the far side of the face too big, endeavouring to bring the nose back to the centre.

Identification images, often used by Police Authorities, provide eyes, nose, mouth, hair, all rather well drawn, and yet somehow the end portrait lacks that overall conception which is vital to a full likeness. What is missing is the perspective of planes. The plane of the top of a table is a flat, smooth surface, running off in every direction, and though the table top may stop, the plane can be thought of as extending infinitely. A precious stone in a ring may have facets created on it. Each of the facets will lie in

achieved by the close observation of all the subtle changes which perspective construction will have helped to reveal. It is the basic principle which sets the theme, but the actual observation which creates the truly sympathetic form (Fig. 134).

When the artist considers a person no longer as a portrait but as part of a larger composition, the descriptive atmosphere can be altered by the view point taken. A person standing in a flat landscape, whose eyes are level with the horizon, which, of course, is the artist's horizon as well, will create the feeling that it would be possible to move through the picture and up to that person (Fig. 135). If the artist wants to create a detached view, so that the observer looks down on the person, then the head of the figure in the picture should be below the horizon (Fig. 136). If two figures of differing heights are observed, perhaps one a child, Fig. 137 shows this scene as if it were observed by an adult. If the observer is a child, or at the height of a child, then the scene would be as in Fig. 138.

When the picture becomes more crowded, as in a market, the eyes of all the figures will

appear more or less on the same line, thus creating the same situation as in Fig. 135, but the lower part of the figure of those closer will drop out of the bottom of the picture (Fig. 139). A crowd seen from above—a multiplication of Fig. 136—can be successful if thought of as a mass forming a block (Fig. 140). Only the tops of the heads will be needed for most, while the shadow will simplify many others. The crowd may only

134 *(Left) A head with a hat emphasising the circular form*

135–141 *Figures in composition*

136

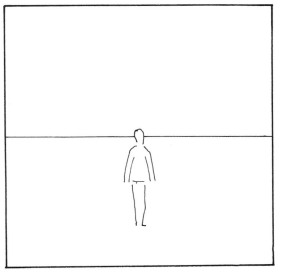

135

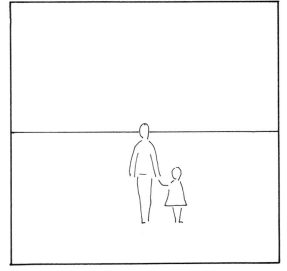

137

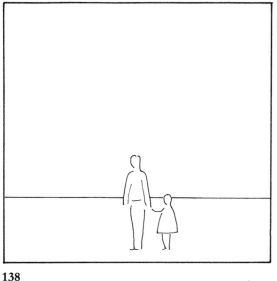

138

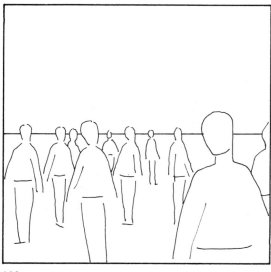

139

140

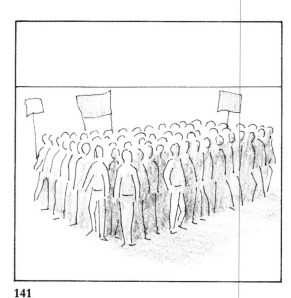

141

require the complete drawing of two or three people (Fig. 141)!

As the domestic animal is likely to stay in one place for some time, it gives an opportunity for study. The lines of the body may seem to be very indefinite but, like the crowd, one must think of the main directions and masses (Figs 142 and 143).

Many wild animals also remain still for periods long enough for studies to be made. In Nature Reserves and Zoological Gardens it is frequently possible to approach animals closely. This is important, for the direction of limbs is not always easy to interpret when colour and markings do their job well—that of camouflaging the form. Plain-coloured surfaces usually

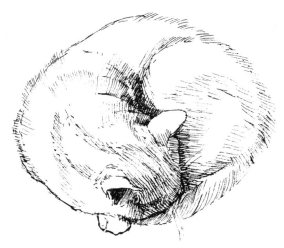

reveal the mass more clearly. Mini pigs sleeping (Fig. 144) look rather like deflated balloons. Folds round the neck and the direction of hair help to model the form, as do the small areas of shadow.

The fur of the capybara (Fig. 145) also gives direction to its solid mass. The two ears and two front feet define the angle of the body and by contrast show how it swells to the hind quarters.

The position of eyes is critical for the construction of the skull, and when only one eye is seen, as in the lion (Fig. 146) or the brown bear (Fig. 147), the form of the skull on the far side

142 *A cat curled up asleep, showing the role of shadow emphasising the deepest creases*

143 *The fur directions of the cat can describe much of the form*

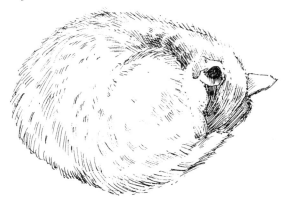

144 *Mini pigs, resembling flattened tubes*

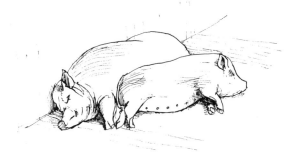

145 *A capybara, the world's largest rodent; a solid wedge shape*

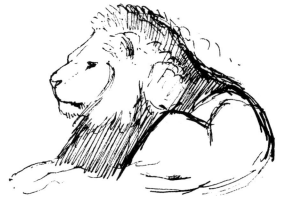

146 *A lion with one eye visible and the position of the other indicated by the form of the skull above it*

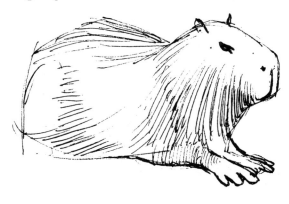

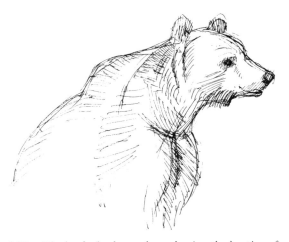

147 *The head of a brown bear showing the location of the eyes and the considerable projection of the snout—more than most stuffed toy bears are given*

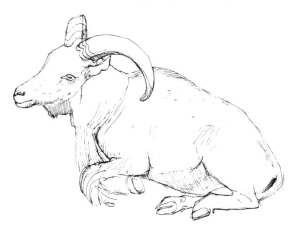

148 *The dominating horns of the Barbary sheep*

149 *A resting pelican showing the two 'halves'—one wing either side of its hidden bill*

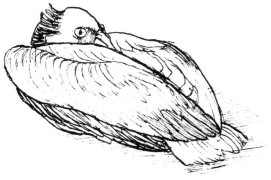

will help to locate the unseen eye and thus clarify the direction and angle of tilt of the skull. The horns of the Barbary sheep (Fig. 148) literally extend this duplication factor. The firm, strong curve will appear quite different on the far side and little is seen as the curve downwards quickly takes the form out of sight.

Further along the body, possibly only the line of the spine on the back will indicate what curve takes place. What must be thought of is the bulk of the body on the far side, out of sight. The pelican resting (Fig. 149), with its head turned round towards its tail and its long bill pressing down between its wings, shows these two 'halves' very well.

The form of the peacock in Fig. 150 is shown to advantage by the help of the branch on which it is sitting. The branch's horizontal form allows the chest feathers to overhang it and the rest of the feathers to lie behind. The long trailing feathers actually grow from the bird's back and here curve downwards and to the left as they press against the ground.

The ground is very necessary for the little burrowing owl in Fig. 151. Here it is standing on just one leg with its foot buried in soft sand. It is the colour variation on the chest feathers and their formation round the form which help the description of the bird.

In Fig. 152, the head of the rhinoceros seems so heavy that it rests on the ground almost like a fifth foot. The placing of the central horn and its relationship with the two eyes starts a sequence of spacing: the two ears and then up and along the spine, the hanging mass of belly lying between the two front and the two rear legs.

The pike also shows these paired elements in its fins (Fig. 153). They show the perspective link between the near and far side.

The giant toad from tropical America (Fig. 154) was an equally happy model, sitting perfectly still for me while I drew. All the main forms on one side are repeated on the other, but the whole made to look more complex than it really is by the mass of bumpy spots on the skin.

The Bactrian camel (Fig. 155) also has complexity in its surface hair, but the whiskers are only an addition to a set of curving cylindrical forms.

74

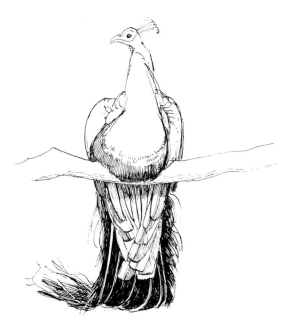

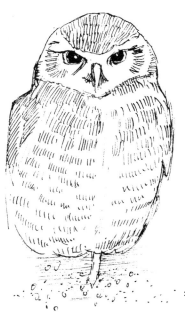

150 *A peafowl resting on a branch showing the shape of its body and revealing the curve of its trailing feathers*

151 *The feathers of the burrowing owl follow the roundness of the body*

152 *The folds of the rhinoceros' skin taking the form back towards its tail, layer beyond layer*

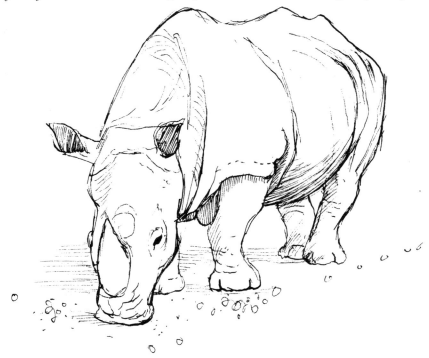

153 *The fins of the pike give measures both across the form and from head to tail*

154 *The bumpy spots of the giant toad are additions to fairly plain large areas*

155 *The unruly hair of the Bactrian camel masks fairly simple cylindrical forms*

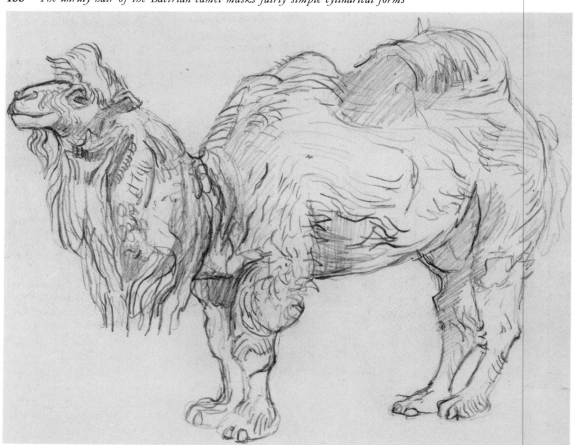

⑧ Landscape, clouds and buildings

To me, clouds are very beautiful. Although not thought of immediately as a subject which involves perspective, they do follow a system of shape and form.

Watching an aeroplane flying over, have you ever tried to guess whether it will fly under, through or above a cloud? I remember the first time I stood on a mountain slope and looked down on clouds. They do have a place and an order, different types of cloud forming at different heights.

Summer cumulus will appear to diminish in average size as it recedes, and it may define its height above the ground near the skyline by forming a horizontal layer which fades into the haze (Fig. 157). If the clouds become larger they will tend to form more complete piles (Fig. 158). Part of one cloud will lie in front of another; some may have holes right through. As the overall mass increases, so the number of areas in shadow may also increase and, of course, some clouds can lie totally in the shadow of others.

It is important to maintain an awareness of the forward or backward movement of these piles. The outline edge, though strongly characteristic of this particular type of cloud, is nevertheless less important than the description of bulk.

In contrast, the feathery high-forming cirrus (Fig. 159) has almost no bulk, but may form useful lines way beyond nearer clouds and, in that way, produces a valuable aid to the description of space. Alto cumulus at medium height (Fig. 160) can form rippling lines which are very similar to the lines of the islands and pools left in the sand as the tide goes out. Strato cumulus, or roller cloud (Fig. 161), shows its name well— indeed I have seen some looking so firm and harsh that its representation on paper looks almost artificial.

When the sun is high in the sky and clouds are isolated, their passing will be sensed as their shadows fall across the land or sea. This occurrence suggests a structure of the air, with mass and volume and lines and directions following all the same perspective schemes, but on a vast scale. This sandwich of space between cloud and earth is one of the most evocative qualities of a summer landscape (Fig. 162).

At first glance one might not see much connection in structure between clouds and trees. But it is the bulk of both which is all important (Fig. 163). A tree is not a flat oval on a stick, though it is frequently drawn like this. A single branch will be surrounded by many others, all radiating out, if unevenly, towards the final little twigs of the year's most recent growth (Fig. 164). Since each branch will have its own shape, while maintaining the particular tree's characteristics, it is difficult to compare one with another for drawing purposes. In Fig. 165 I have drawn the same branch in four positions. Fig. 166 uses the idea of the plane. Each branch lies in its own plane and, if a rectangle of that plane is visualised, a clearer sense of direction will result.

The winter tree shows this underlying idea, but of course the structure is not neatly even, and the perspective of the branches must be searched out. Consider the main trunk first; then the main branches, watching for those going away on the far side of the tree, and those coming forward. Tree branches taper. A branch growing towards the observer will actually get thinner as it gets closer. Yet, because of perspective, the whole branch will appear to swell as it comes nearer (Fig. 167). This is a situation

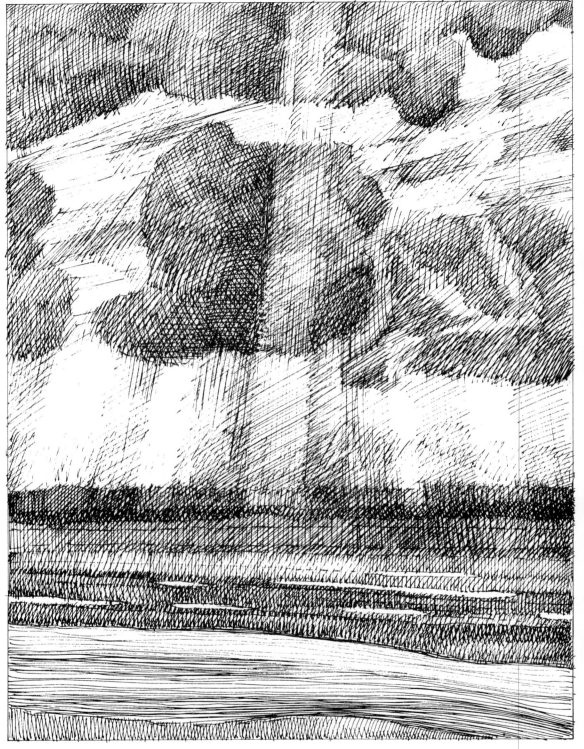

156 *Study of clouds*

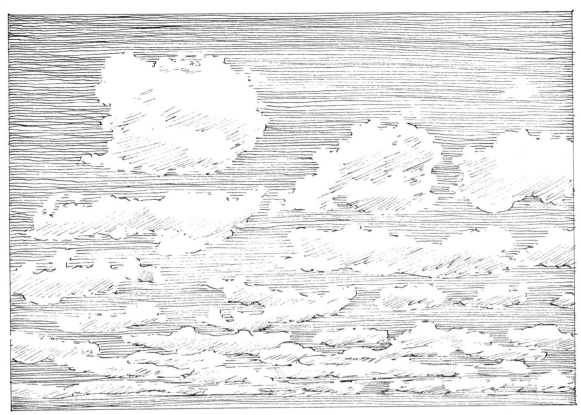

157 *Summer cumulus receding to the distance*

158 (Below) *A larger mass of cloud with increasing shadow areas*

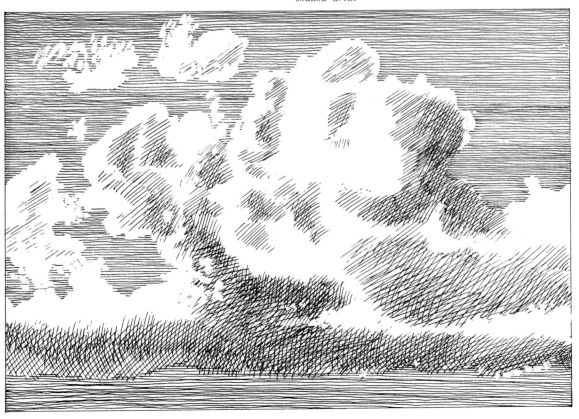

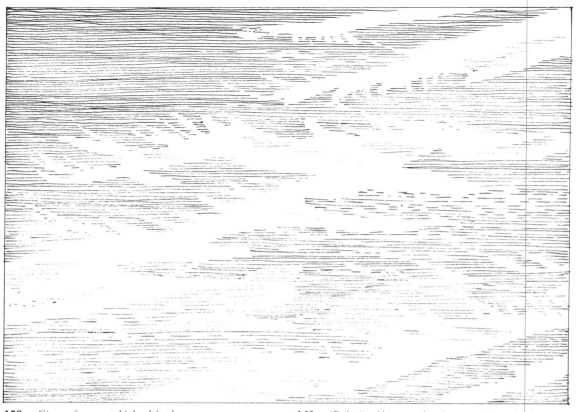

159 *Cirrus forms at high altitude*

160 *(Below) Alto cumulus forms various rippling lines giving perspective direction*

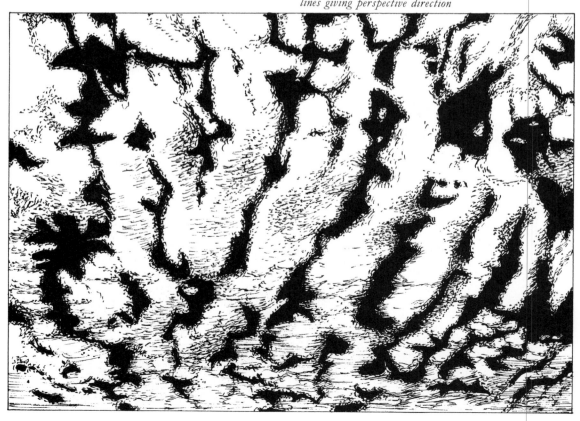

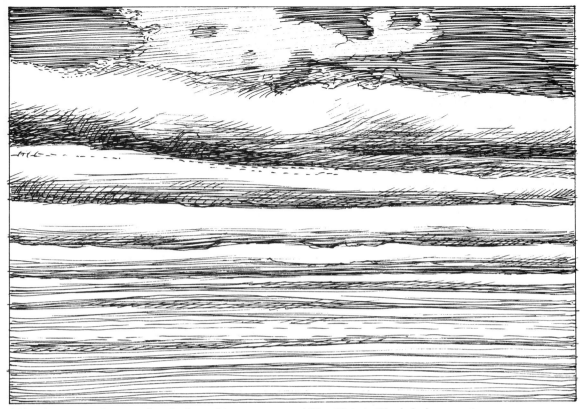

161 *Strato cumulus, or roller clouds, making diminishing bands across the sky*

162 *(Below) Cloud shadows running across a Norfolk landscape*

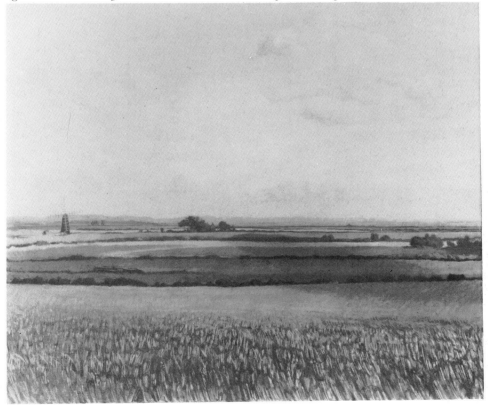

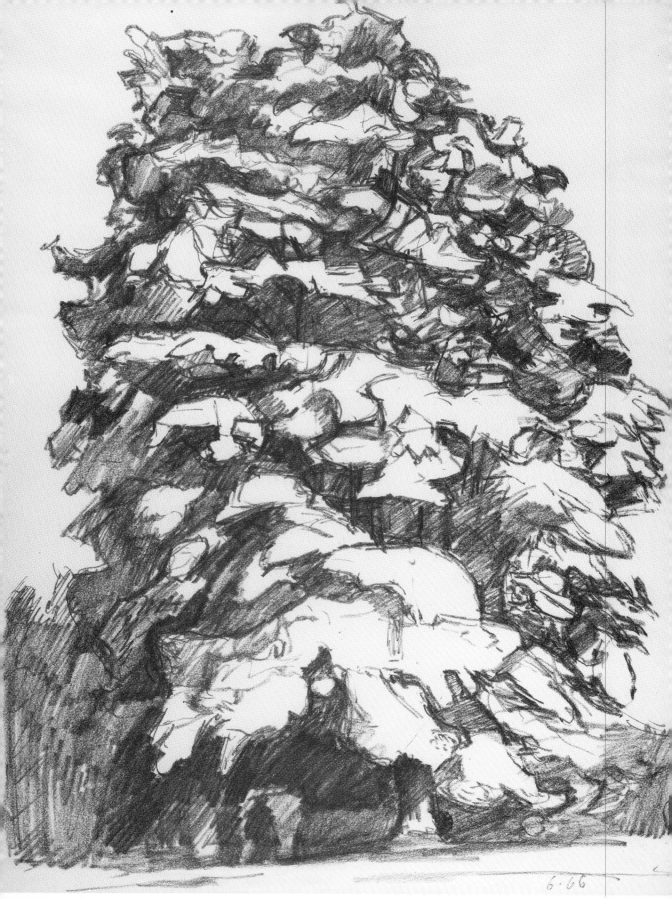

6·66

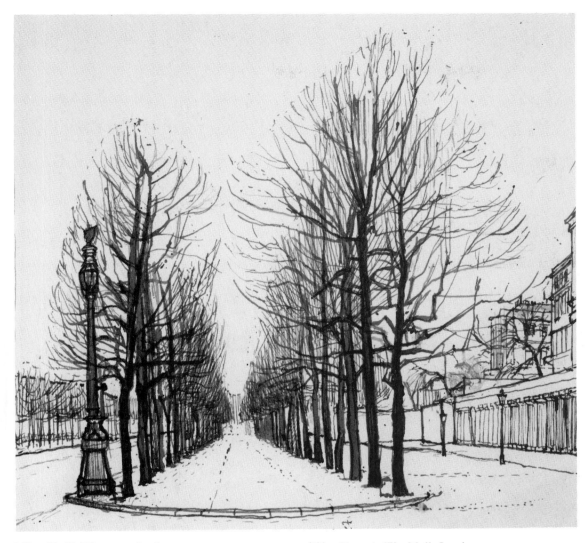

163 (*Left*) *The mass of a large tree* **164** *Trees in The Mall, London*

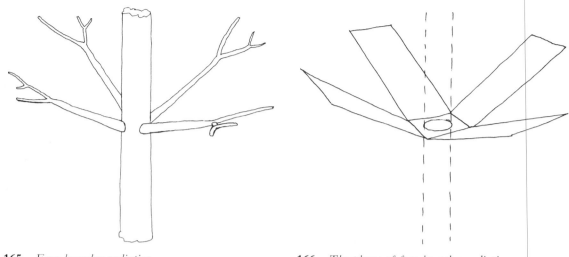

165 *Four branches radiating* **166** *The planes of four branches radiating*

167 *A tree with close branches showing how one branch, which would in actual fact be thinner, will appear thicker than the main trunk*

where form and perspective may cancel out one another. In isolation this is difficult to make clear in a drawing, but probably it will be clarified when the other branches are not being seen in this way. On these main elements the smaller, rather less critical branches and twigs can be developed. Because of the great number, it would be wise to be selective and not put in all the smaller twigs, for the marks made by the pencil or brush can make the end result too dense.

The tree in leaf shows the mass more readily. The main branches of a mature tree with a large span will move outwards. The gap and likely shadow between these clusters of leaves will help the description of the form (Fig. 168). The shadow of the whole tree cast on the ground can also help to clarify the bulk.

So, in all trees, there will be the consideration of the whole. The characteristic shape coming from the accumulation of the branches. Some coming towards the observer, some side on and some going away. The overall colour and tone of the leaves can also assist in clarifying particular shapes and defining one tree from another (Fig. 169).

The leaves on those closest will be the largest, those on the furthest branches the smallest, so, if the mature leaves are of the same size, here will be another element to help the space description. Clusters of blossom work in the same way and, because of their pale tone, show up even more clearly than leaves (Fig. 170). Even if clusters vary in size, their average diminution will still be evident. The landscape painter, seeking the picturesque, will use the barkless, dead branch as a

168 *Branches in leaf showing gaps between*

169 *Three trees of various tone*

170 *Blossom on a tree and similar clusters diminishing into the distance*

171 *The cloak of snow on a tree*

focus of interest, for it will give another valuable contrast of a pale tone while its shape and direction will still follow that of its live companions.

Under conditions of snow some strange and beautiful effects are added to the tree form (Fig. 171). Directions will change, as branches are weighed down by their new burden. Some snow conditions will add little white tops to every twig, the thickness being directly related to the thickness of the branch, so little twigs will have little snow lines and thicker branches, thicker lines. On evergreens, the support can be considerable and a near solid pile of snow can result.

Clouds and trees comprise some of the main elements of a landscape. Trees, like people, can create both scale and distance in a composition. It is not hard to find a view of fields with trees and bushes dotted about the perimeter (Fig. 172), and furrows can provide strong lines of direction. A simple landscape can be effectively drawn from imagination, needing little beyond the most basic guide lines of perspective.

Starting with a broad picture shape, which in itself helps the feeling of space, two horizontal lines are drawn, dividing the picture into three roughly equal parts. Above the top line a wavy line is drawn to represent distant hills and this area can be shaded. Between the two original horizontal lines, two further dividing lines are drawn, producing bands which increase in depth from top to bottom (Fig. 173). Fields are not

always ploughed in the same direction and, by making the lines in one area head towards one vanishing point while those in another have a different direction, variety will be added (Fig. 174). By thickening the boundary fences, or hedges, and the addition of trees and bushes, a simple landscape results (Fig. 175). If the land surface is rolling the lines will curve slightly over the humps (Fig. 176).

Interesting and complex pictures involve multiple aspects of perspective. Views looking up and down can create much more pictorial excitement. Rocks with a valley below give the observer of the picture a feeling for what is happening (Fig. 177). At this stage one begins to move away from hard and fast rules, and a degree of artistic licence helps the creation of a situation. In this scene it is necessary to view the figure from below in order to help the feeling that the climber is going up. In the same way the horizon needs to be kept very low in the picture in order to give the impression that there is a long way to fall to the fields below. The true vanishing point for the figure may be higher than that for the land. By dropping the land horizon the feeling for height is emphasised.

Occasionally this artistic licence needs to be used even in architectural drawing. I remember drawing the main façade of a large country house and, although I could grasp the overall proportion, when I came to draw the towers at

172 *Fields from Glastonbury Tor*

173 *A basic landscape*

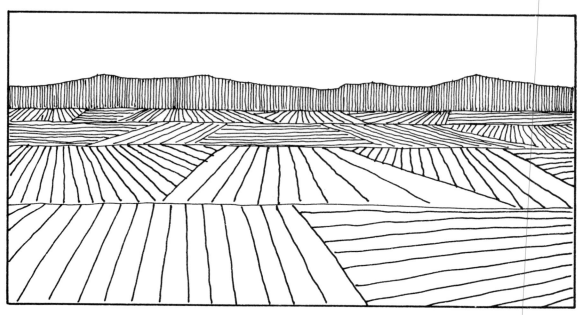

174 *Completed fields*

175 *The addition of hedgerows and trees*

176 *A rolling landscape*

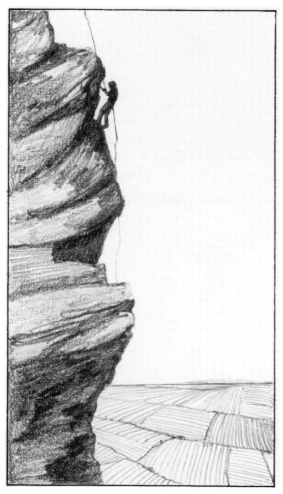

either end, each had its own perspective from my view point midway between them. I could see two sides of each tower so that I was really drawing two views, one slightly to the left, the other slightly to the right. Though the tops of the towers and the main wall between were in fact in line, and should therefore have been drawn parallel, I felt I had to allow the top of each tower to drop away slightly, to their own vanishing points left and right, in order to make the picture look convincing (Fig. 178).

A violent upward or downward view can be stimulating to the eye. From a high building, roof tops present a myriad of directions. The fact that the horizon is well beyond the top of the picture adds to the feeling of an extreme downward direction (Fig. 179).

Buildings are frequently involved with strong directional views and when looking upwards, lines, which in a straight-ahead view would be drawn vertical, will be observed to converge upwards (Fig. 181). But, as if to help the artist, there are some impressive structures which taper upwards anyway. The tower of an East Anglian windmill shows this particular aspect (Fig. 182). The twisting planes of the sails show the important link between function and perspective direction. The pagoda shows well an upward taper and how the amount seen of the underside of each floor increases as the eye moves upwards (Fig. 183).

177 *A climber with a valley below, using two vanishing points to emphasise height*

179 *(Right) Roofs of Florence from Brunelleschi's dome of the cathedral*

178 *Two parts of a building, each with its own vanishing point*

Florence 27·7·68.

5.8.68

180 (Left) Beachy Head lighthouse, its considerable structure dwarfed by the cliffs from which it is viewed

181 Palazzo Vecchio, Florence—a view creating neck-ache for any artist!

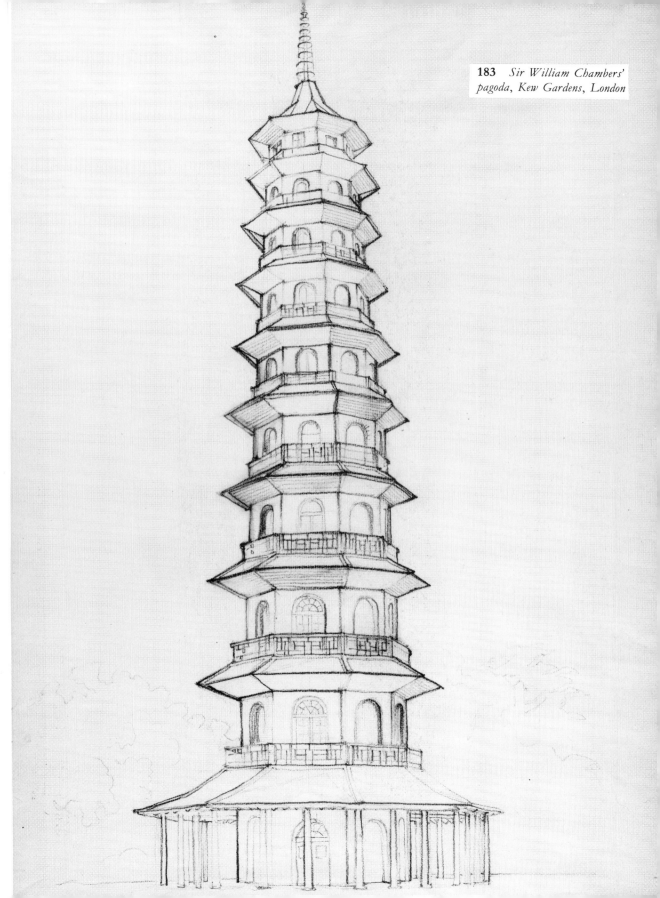

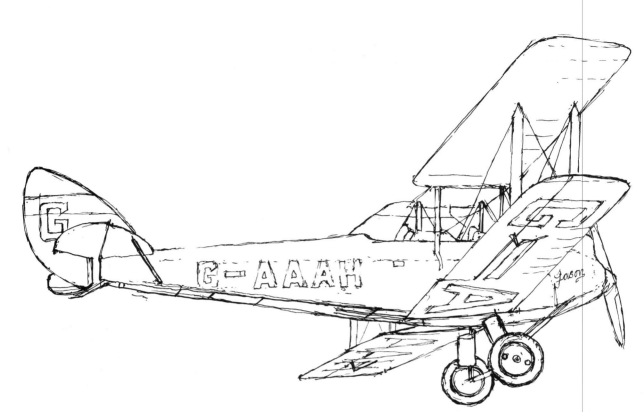

184 *Jason, the De Havilland Gypsy Moth in which Amy Johnson flew from England to Australia in 1930. It is now in the Science Museum, London. The wings have considerable complexity for in this upward view not only does dihedral—that is an upward tilt towards the tip—have to be realised, but a slight angling backwards as well. Thus the far wings are seen more obliquely than the near pair*

⑨ Water and boats

The classic horizon is where the sea meets the sky (Fig. 186) and though for many water produces the greatest expanse of flat surroundings to be seen, it is nevertheless hardly thought of as flat or even still. A young painter's efforts at sea painting will, I predict, be blue with little half moons of white paint added all over to represent waves, or waves breaking. I think this conception can remain for a long time. So, if the desert is a quiet, flat land, what of the sea and its movement?

The water of a wave does not really move until it breaks. That is why if one throws a piece of wood into the sea it will be slow to change its position, merely moving up and down the shape of the wave.

There will be water flow along a coast and a tide movement raising or lowering the level of the water. Wind will add complexity to this and create, according to its strength and direction, the shape of the wave. If the wind becomes gusty then 'white horses' appear as the tops of waves are blown over and fragment in foam. Even on a calm day waves break on the shore where the returning water from a previous wave runs back down the beach and meets the next incoming wave. This undermines the new wave which breaks into foam and scuds up the beach.

If the sandy shoreline is flat, the remains of waves form tiny layers of water running over other layers in gradually subsiding half moons, until, losing momentum, they also lose their identity and become patches of scud sliding back down the beach to rise up on the face of a new wave, patterning the surface of the water (Fig. 187).

The structure and system of movement will soon make itself clear when observed while standing near its edge (or even in the shallow water itself) and looking along the coast. It is very useful that there will be a similarity in the size of waves and that the movement endlessly repeats itself, for the artist needs to refer to the subject a considerable number of times in order to draw a truthful image.

From the beach, looking out to sea, there may be 'stripes' of wave type (Fig. 188). Starting at the water's edge, curves of wet sand will change to thin layers of dying waves. A little way out a range of waves will be breaking as they come in. Beyond this, the waves will be forming but not breaking, and then the forms become blurred into a delicately freckled surface stretching to the horizon. If the waves do break further out then their size in perspective will diminish.

Breakwaters will produce good firm lines against which the shape of waves can be contrasted (Fig. 189).

Boats inevitably will come into this scene sooner or later (Fig. 190). A well-shaped toy boat held in the hand will show all the views that one may wish to draw. The shape of boats is compound and of course there are many variations. Not only do they swell from stem to stern, but they have a rake which gives the deck line a curve.

Boats pulled up on the beach are easier to consider because they don't swing at anchor (Fig. 191). Thinking of the packing case idea can help, for almost all boats are regular. I say most, for when drawing gondolas in Venice I discovered that they are not! They have a special asymmetrical shape to counter the gondolier standing at one side with his oar. The imaginary packing case will only touch the broadest point

99

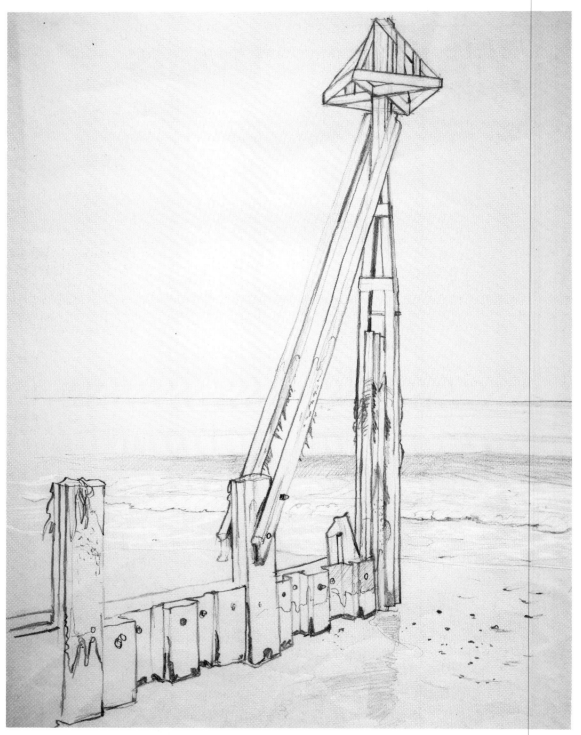

185 *Groyne at Waxham, Norfolk*

186 (*Above right*) *A water colour showing white horses leading to the classic horizon*

187 (*Right*) *Half moons of dying waves at Mundesley, Norfolk*

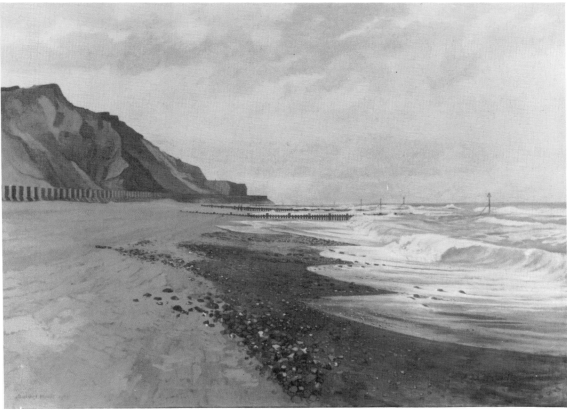

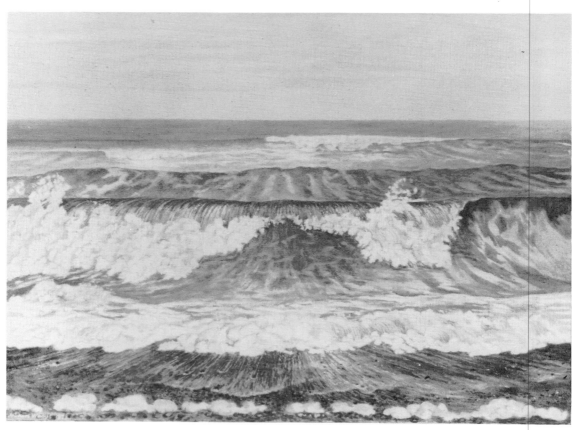

188 *Stripes of wave type—Blakeney Point, Norfolk* **189** *(Below) The contrasting element of a breakwater at Waxham, Norfolk*

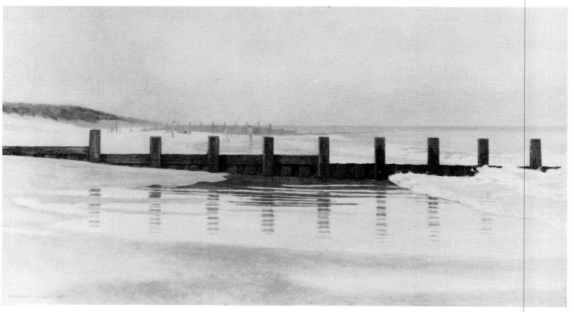

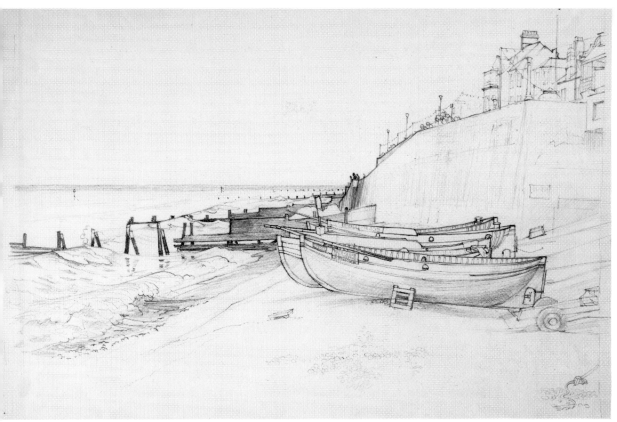

190 *Drawing showing the compound shape of boats at Sheringham*

of the beam (Fig. 192). The packing case edges will lie parallel to a line running between the bow and midstern. Only use the case in order to keep the main directions of the structure regular. The use of horizontal and vertical lines will do the real job of tracking down unusual curves. Once the main shape has been approximately established, attention should be given to construction or colour lines because when these are developed they are likely to help the overall shape. In fact this sub-division of any shape is of enormous help in drawing the whole.

The traditional clinker method of boat building involves many lines of planks along a hull (Fig. 193). The way they taper and curve can be analysed by first of all locating the keel line. If viewed from the stern, its width should be compared with the amount seen of the boat's side. The perspective of each part must be reasonably right if the boat's structure is to look convincing.

Ships with sails provide the painter with vertical forms which contrast beautifully with the horizontals of the water and sky. However, sailing boats lean over and booms swing out. The angle of the mast can be set against an imaginary vertical and the hull of the boat must also lie at this angle. The wind pushing against the sail will cause the sail to lie at an angle to the hull; this will not be a flat plane but will curve under stress.

Different boats will have differently shaped sails and according to the wind position and the direction of travel, so the appearance to the artist can be surprisingly varied. This can be seen in the simple drawings of a Bermudian rigged yacht passing by (Fig. 194). The appearance of a little lug sail dinghy can change very quickly, especially in blustery wind. Fig. 195 shows two sequences of movement. In Fig. 196 the dinghy is almost becalmed.

There is sometimes the mistaken idea that a

103

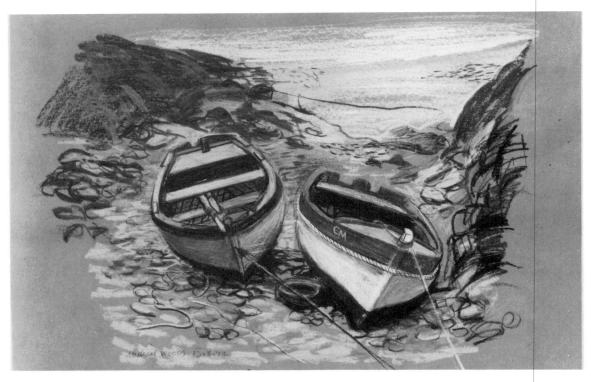

191 *Two boats on a beach in Normandy*

192 *(Below) Basic directions of boat structure*

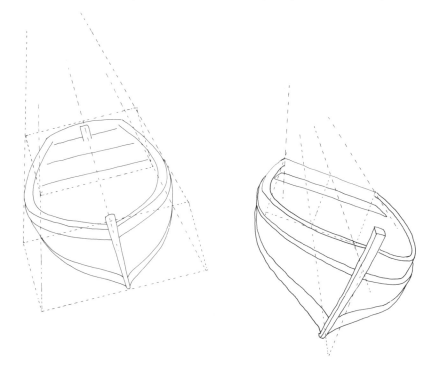

104

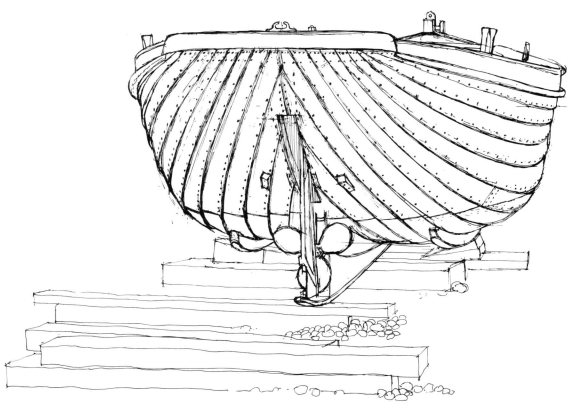

193 *Clinker construction of a fishing boat at Hastings, Sussex*

194 *(Below) Eight variations of shape seen as a yacht passes*

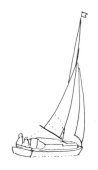
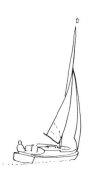
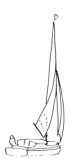

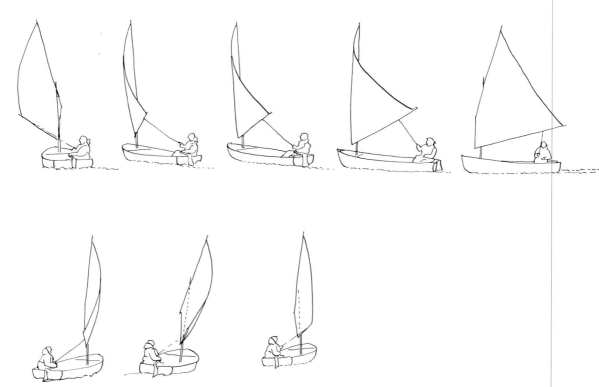

195 *Variations in position of a dinghy*

196 *The dinghy almost becalmed. Notice how the weight of the person is tilting the boat to that side*

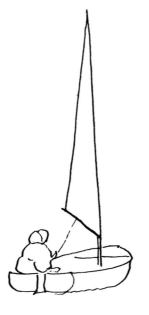

reflection is like a blot of ink in a folded piece of paper: a near duplicate image (Fig. 198). This is misleading. There can be a similarity when an object is seen reflected at a considerable distance when the angle of the eye to water is extremely oblique (Fig. 199), but there the similarity stops.

Figure 200 shows a simple round pole which is standing in water so that it is possible to see its top as an ellipse. Note that the curvature of the point where it meets the water is more curved than the top, for it is slightly further away from the eye. The water must be assumed to be absolutely still and flat. The image appears as if the structure were there twice, the second one upside down and fixed to the bottom of the first.

The reflection will not equal the height of the pole to the top of the water, for the image in the water will be continuing away from the eye and therefore will be shorter than the original. What in fact is happening is that the eye observes the pole descending to the water surface, which acts like a mirror. The eye believes that it sees the reflection going on down, but in fact, following

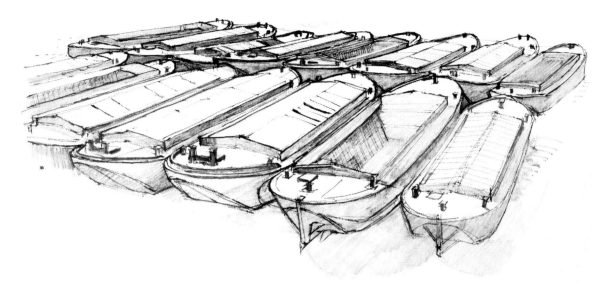

197 *Barges moored on the Thames showing the appearance of near similar forms, changing by the perspective. The artist must be alert because moored boats will swing while at anchor, and angles will change*

198 *A duplicate image made by a blot*

199 *A distant pole having a similar reflection*

200 *A close post showing its downward taper and the continued taper in the reflection, which is also shorter than the post itself*

the rule that the angle of incidence equals the angle of reflection, the image seen will be as if the eye is at the water surface looking up at the actual pole (Fig. 201).

Using the bridge constructed in Chapter 5, I have drawn it as if it were crossing a river with the near side standing in the water. The reflection of the bridge will show more of the underside of the bridge arch than otherwise could have been seen (Fig. 202). All the construction lines will continue in the same system as if the builder of the bridge had actually constructed the reflection as well. Thus, the top edge in reflection will still have VP1 as its vanishing point, and the line joining reflection keystone to reflection keystone on the far side will still aim at VP2. Once again, the overall construction lines can be helpful to plot the main position of parts, even if they are obscured in reality.

But I need hardly add that even river water is rarely still. When the water is ruffled by wind or flow, the rolling surface will reflect from more

201 *Diagram of image directions to the eye*

eye

water surface

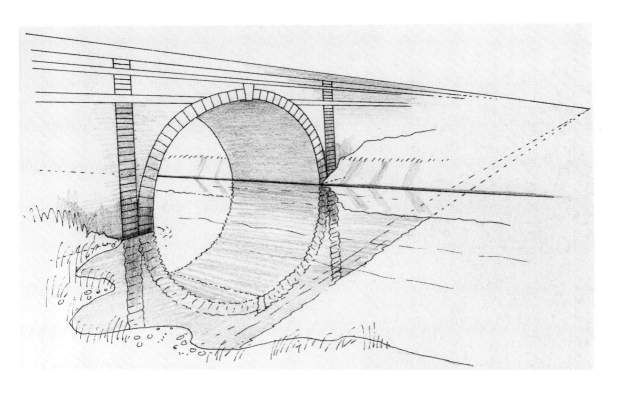

202 *Bridge and its reflection revealing more than it is possible to see in the actual structure alone*

203 *(Below) The various directions of reflection due to surface waves*

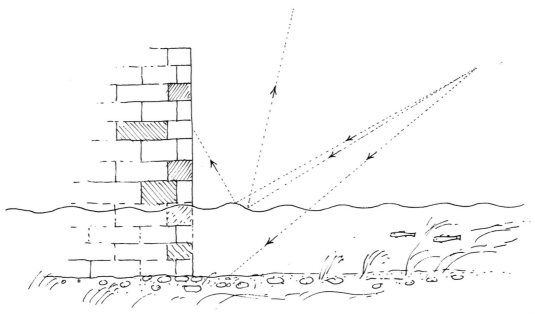

204 *A bridge with two arches showing how much smaller the further arch appears and how its reflection also emphasises this*

205 *A boat in a Normandy harbour and its clear, if wobbly, reflection*

than one place (Fig. 203). According to what is at the end of the arrow—the point of observation—the lower pointing directions will find, perhaps, the bridge. The higher pointing ones will find pale clouds, blue sky. Thus the eye receiving these rays will find part bridge, part sky and, if the water is clear, even part of the river bed itself.

In the same way reflections of boats in broken water will be mixed with sky and cloud and so fragmented that they will not be at all obvious. When moored in still water the reflection will be very clear, yet showing the most marvellous serpentine wriggles as the slightest movement of the water surface distorts the crisp lines of the boat above (Fig. 205).

10 Perspective in use

The forceful impact of perspective can perhaps be demonstrated by cutting out a drawing. A building is ideal for a semi-three-dimensional image (Fig. 207). Draw a horizontal base line on a long sheet of pale paper and then draw two sides of the building as if viewed from one corner at ground level. Keep all construction lines either running to left or right, including the tops and bottoms of windows and doors. All verticals will be quite vertical. Heavily shade the glass of any windows and lightly shade one side of the building. Cut out the drawing and fold it down the line of the corner nearest the viewer, making an angle of about 135 degrees at the back (Fig. 208). The piece of paper will then stand up and the fold will increase the effect of perspective. If lit from the side not shaded, the other shadow side will look even more convincing.

A whole complex of buildings can be created in this way (Fig. 209). One could even draw buildings on site and cut them out later. Modern flat-topped (Fig. 210), or classical buildings with no roof seen, will give the best results, as a sloping roof shape will not fold convincingly. Towers (Fig. 211) and monuments (Fig. 212) can add variety.

A rocket conjures up something of the excitement of ever-expanding space exploration. Using a dark piece of paper and a white pencil or crayon, draw an 'early' three stage rocket with two lines converging to give the main directions (Fig. 213). A cylinder drawn within the full width of the guide lines will represent the first stage, a slightly narrower one for the middle and narrower again for the furthest top stage. A pointed cone end makes the tip. Two fairings will make the transition between the sections. A

nozzle should be added at the 'working end' to make it look more impressive. Remember that the ellipse of the closest end will have the smallest curve and as the rocket recedes away from the eye the curve will increase slightly. Shade the cylinder as if the source of light was above. Do not make the lightest shading at the top, but about one-quarter way down. Each part of the rocket will be shaded in the same way including the nozzle. When complete cut out the whole shape. Place it on a contrasting background and it will have an effective three-dimensional quality.

Another object which lends itself to being cut out is the hot air balloon (Fig. 214). Its regular form has a curvature which works in two directions, side to side and top to bottom. This particular balloon has panels which bulge between the main seams, and the amount seen of these panels diminishes considerably at the extreme left and right. As the shape curves upwards and over, the bulge of the panels is emphasised. The bottom of the balloon is shown by its skirt and the opening is seen as an ellipse. A strong pattern will help to show up the form. The overall shape should be cut out with as smooth an edge as possible and it is optional to cut out the holes between balloon and basket. If drawn on card it can be hung from a thread.

A figure drawn and then cut out and placed on a contrasting background will heighten the

206 *Radcliffe Camera, Oxford in which the drawing of the dome is nearly complete, but the lower portions show guide lines and general structural relationships. Note how the gaps between the pillars diminish to the sides and how the arches at the base are seen more obliquely at the sides*

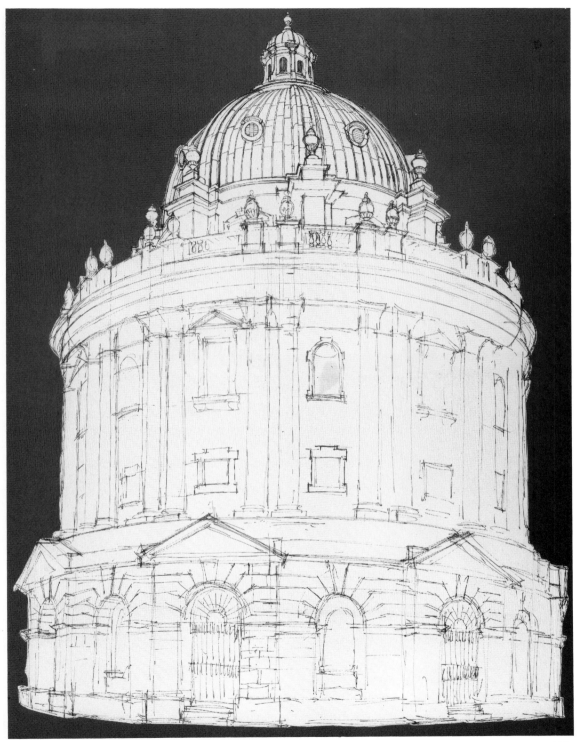

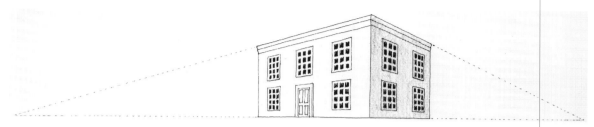

207 *A simple house with shading on one wall, prior to being cut out*

208 *(Right) Photograph showing the building cut out and folded so that it is free standing*

209 *A whole cluster of buildings can be achieved and made particularly interesting if a variety of heights is used*

210 *The basic modern flat building in its flat state before folding*

211 *A tower in its flat state before folding*

212 *An obelisk in its flat state before folding*

213 *A rocket*

214 *A hot air balloon*

215 *Girl playing a guitar. This particular subject was drawn from life; great care was given to the cutting out so that the boundary maintained the form represented*

three-dimensional effect (Fig. 215). One rather impressive trick of perspective is to draw a figure lying on its back from the head end (Fig. 216). This extreme view should leave out any ground or shadow on the ground. Then, when complete, turn the drawing upside down (Fig. 217). Abracadabra, the figure seems to be floating in mid-air!

216 *Figure drawn from the head*

217 (Below) *The drawing shown in Fig. 216, turned upside-down, creating the view of a figure as if floating in space*

Drawings which are able to be interpreted in more than one way are not uncommon. Alternative interpretation to road signs can be very amusing. Is this gentleman in his Wellington boots digging into a pile of earth or is he trying to open an umbrella (Fig. 218)? The role of perspective, and visualisation, certainly becomes involved with direction arrows for traffic flow. The arrow pointing straight up into the sky means a direction of movement straight ahead—in fact a 90 degree difference (Fig. 219).

There are also drawings which can be interpreted in more than one way. Is the box in Fig. 220 seen from above, or does the drawing describe just three surfaces seen from below? It relies on nil perspective or no convergence or divergence of the lines. Drawn again from both possible views, using perspective, there is no muddle as long as one knows the object is made with rectangular parts (Fig. 221). If this is not known there is still a muddle, with Fig. 222 looking as if it might describe a slightly wedge-shaped box.

There are many fine and exceedingly clever

218 *A road sign used for warning of road works which can be interpreted in more than one way*

219 *Traffic flow direction arrow pointing straight up into the sky, conveying to road users a direction straight ahead*

220 *A simple drawing which can either be a box seen from above or three sides of a lid-like structure seen from below*

221 *A simple drawing of a box seen from above and likely to be less confusing because of its use of perspective*

222 *Three sides of a lid-like structure seen from below and drawn with perspective*

drawings involving the cunning misuse of perspective. They depend on establishing what seems to be a possible real location, but by taking some elements from or to the wrong place a visual argument ensues, fascinating the brain. For those who just enjoy looking, this sort of draughtsmanship conjuring can give much enjoyment, but for those who actually draw and want to do so with increasing sureness, art of this type can be a hazard. Fig. 226 is an example of this and by breaking down the drawing into its parts, it is possible to see how it disturbs visual understanding. All the lines going in one direction are drawn parallel (Fig. 223). Two cubes (Fig. 224) have a simple relationship,

223 *A single isometric cube*

the nearest A overlapping the furthest B. The addition of a third cube C (Fig. 225) could also have a normal relationship with A and B, but the dotted part of B is drawn firmly while the two lines of C which overlap B are left out (Fig. 226). Turn the drawing through any angle and the visual tangle remains the same.

Sets for theatrical productions frequently depend on illusion: the task of creating a bigger space than that which actually exists on a stage. The illusion of higher rooms, space beyond, pillars and mouldings, drapes and decoration, often are all created on a flat surface. All these

121

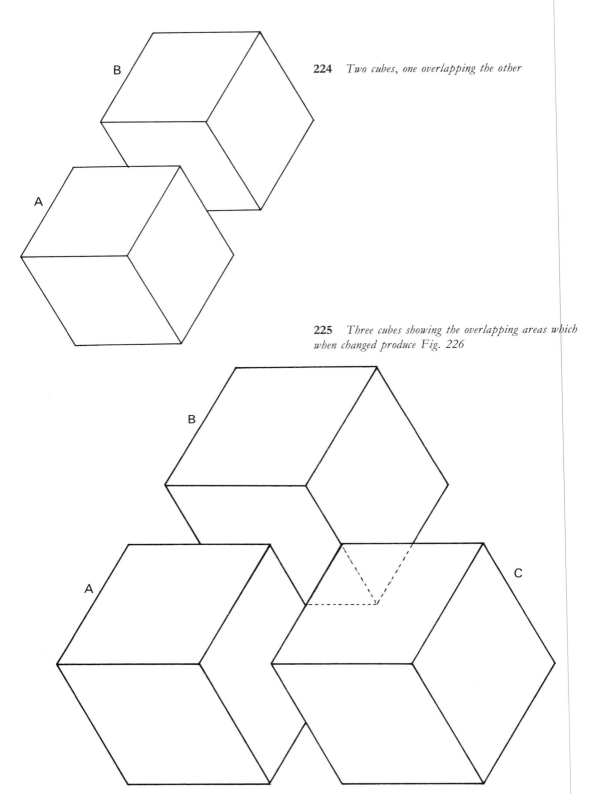

224 *Two cubes, one overlapping the other*

225 *Three cubes showing the overlapping areas which when changed produce Fig. 226*

122

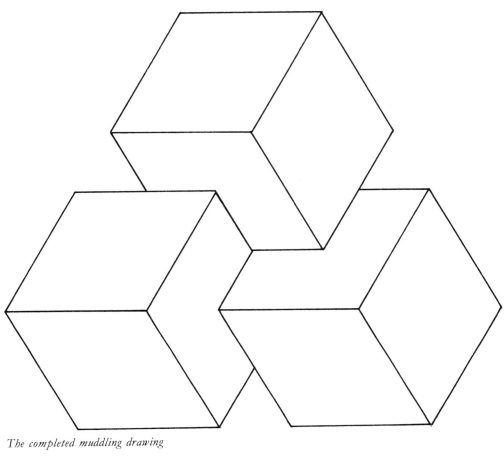

226 *The completed muddling drawing*

227 *Ground plan of the final flats on stage*

descriptions depend on some aspect of perspective, but often on a stage there will be some real recession as well.

A set comprising three walls could have its back piece perfectly flat, with the left and right hand walls angled downstage towards the audience when finally set up, as in the ground plan (Fig. 227). A horizon line about eye height of the actor on the stage should be drawn, say 1.5 metres (5 feet) up from the stage floor. A vanishing point will be established in the centre of the back flat on the horizon line (Fig. 228). A guide line is drawn from the top left-hand corner of the left flat to the vanishing point and likewise from the top right-hand corner of the right flat to the vanishing point. A horizontal line is drawn joining the points created by the intersection of the vertical junction of the flats and the perspective guide lines. The area above this line can be painted black to emphasise the top line of the set and to mask any variation in the height of the flats (Fig. 229).

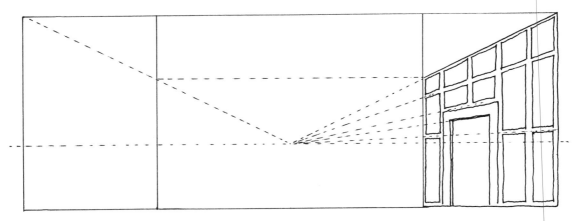

228 *The layout of the perspective on the flats*

229 *The final appearance of the stage design with the blacked out upper areas assisting the depth created*

A scale model made of card or stiff paper will clearly show how successful the design is and enable planning to take place. By making the model to scale it allows the design to be scaled up and transferred, element by element, to the actual flats, string and chalk serving to lay out the guide lines.

Actual doors will be about 2.1 metres (7 feet) high. These will have to be made correctly, but from the lintel and above the perspective on the two sides of the set can be developed. Wooden panelling might be appropriate for the play and this type of regular design can look particularly effective in perspective. The back flat will have no perspective, but the lines of the panelling will follow through from the sides.

A development of this is to use perspective on the sides and to continue the scene onto the back wall. It is quite difficult to make the junction from side to back wall without an apparent change of direction. All the audience will not be viewing from the same point so one way to

124

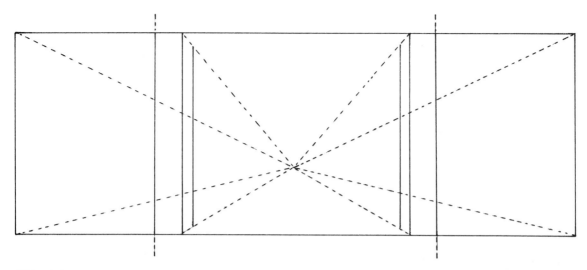

230 *The basic perspective layout of a hall*

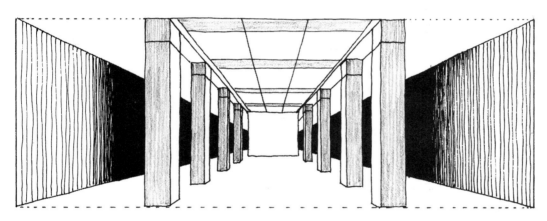

231 *The completed appearance of a pillared hall*

make the junction look comfortable is to make the corner terminate with a whole height element like a pillar. The appearance of the perspective on the flats will then seem acceptable from whatever position they are viewed. Pretend the set is a large pillared hallway, for example, and the interior reaches away into the distance. Using a set of stage flats as before, and with a vanishing point in the same centre position, guide lines can be drawn as in Fig. 230. A large pillar may be painted on the very right-hand side of the back

flat and another on the left-hand side. Any repeated regular structure will help to create the perspective, as will the wall line at the extreme left and right (Fig. 231). The ultimate vanishing point need not be shown, for a wall can mask it and this could be the site of some appropriate image suitable to the play.

Some sets may just need isolated pieces to create a particular idea. The use of the flat cut out can be most successful when the subject is drawn in perspective. Fig. 232 shows the original

125

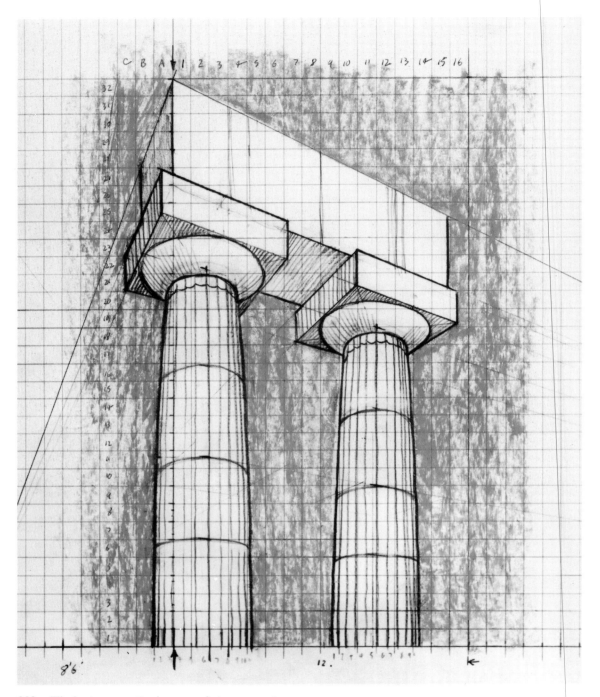

232 *The basic perspective layout made in preparation for the stage design*

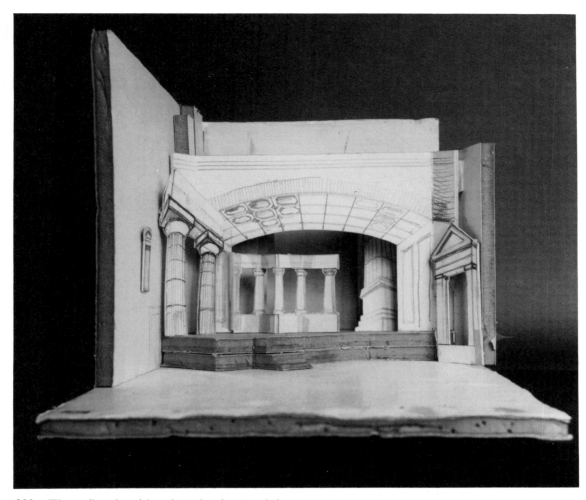

233 *The cardboard model made in the planning of the production*

plan of two Greek pillars, laying out the perspective, and Fig. 233 shows the cardboard model used for planning the production. Fig. 234 shows the final Greek pillars made about 7.5 metres (24 feet) high, but though suggesting three dimensions, painted on a totally flat surface.

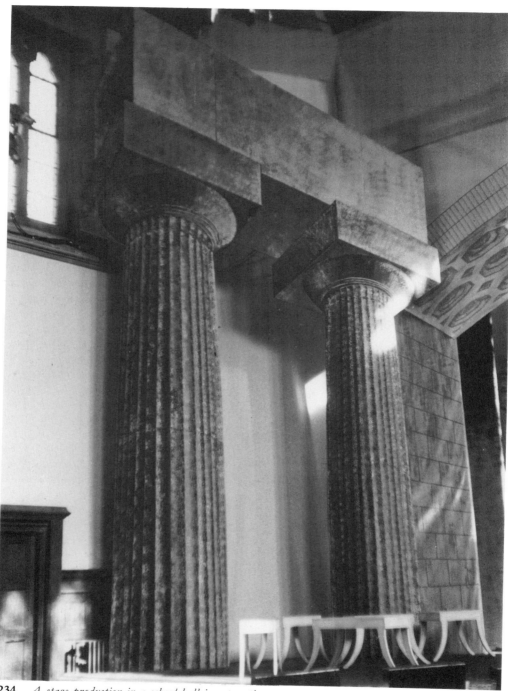

234 *A stage production in a school hall incorporating two Greek pillars, painted with the illusion of three dimensions on a totally flat surface*

11 Art and architecture

There are some great artists, both painters and architects, who have used perspective in a notable way. It is rewarding to look with a searching eye at the work of those who have used this knowledge to advantage.

The work of Giovanni Battista Piranesi should be looked at (Fig. 235). He was a brilliant draughtsman, who influenced many architects. I particularly like the fact that the etchings he produced describe not only the tremendous atmosphere of the buildings, but also how they were constructed. Many of his works go beyond fact and are an imaginative interpretation of the appearance of buildings and their environment.

Sir Stanley Spencer makes marvellous use of receding objects (Fig. 236). His painting,

235 *The basic elements of one of Piranesi's etchings*

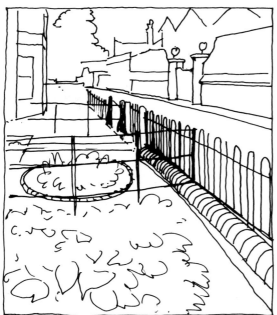

236 *The basic forms in a painting by Sir Stanley Spencer*

237 *The placing of the boats in a Signac painting*

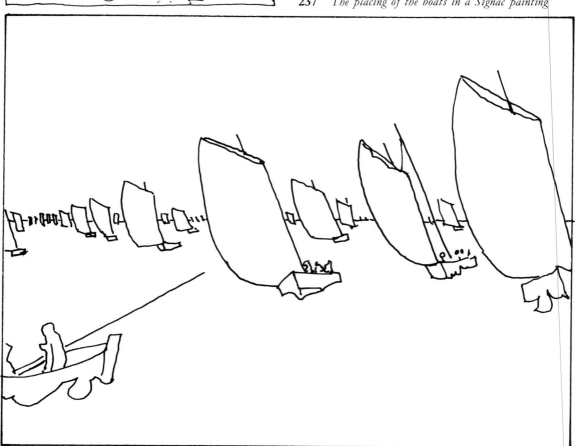

'Gardens in the Pound, Cookham', shows flower beds and railings receding into the picture. Other compositions use the diminution of figures to create the feeling of a dream-like space.

Amongst the Post Impressionists I particularly like Signac's painting of boats with red sails, which are in great profusion across the sea, becoming smaller and smaller towards the horizon (Fig. 237). Vuillard's 'The Red Mantlepiece' in the National Gallery in London has always attracted me (Fig. 238). It shows a simple, large, marble fireplace with a lovely clutter of objects, but the dramatic angle he has taken turns the ordinary into a great painting. Rembrandt's painting of Margaretha de Geer, also in the National Gallery, dramatically emphasises the nut-like head by the crisp, elliptical form of the ruff encircling the neck (Fig. 239). Vincent van Gogh's 'The Chair and the Pipe' is a strong

238 *Vuillard's 'The Red Mantlepiece' seen receding into the picture*

239 *Part of a painting by Rembrandt of an old lady showing the encircling ruff*

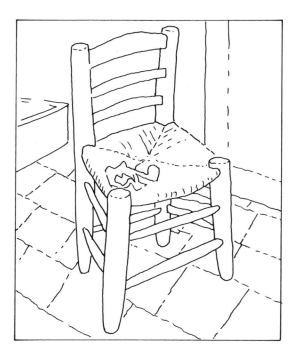

240 *The main directions of van Gogh's picture 'The Chair and the Pipe'.*

242 *(Right) Chirk Aqueduct—a classic example where the strength of perspective view has assisted the creation of a fine painting*

241 *Cotman's beach scene lacks hard perspective lines, yet creates more feeling for perspective than some compositions which do*

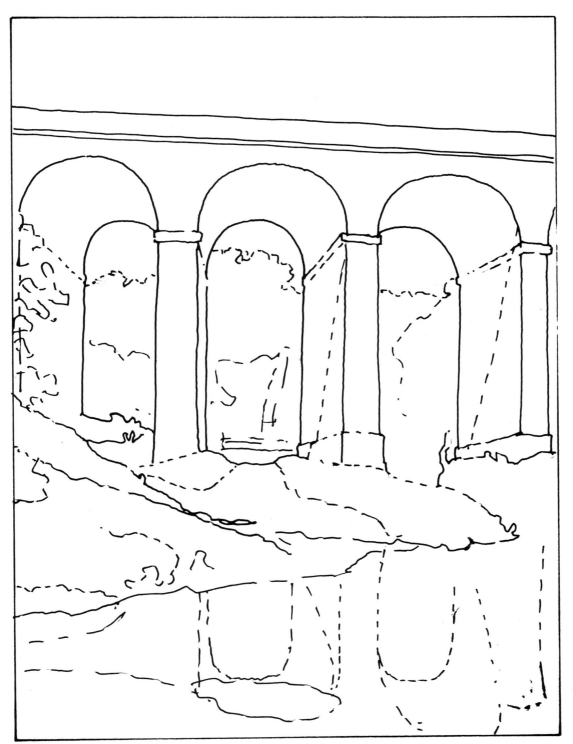

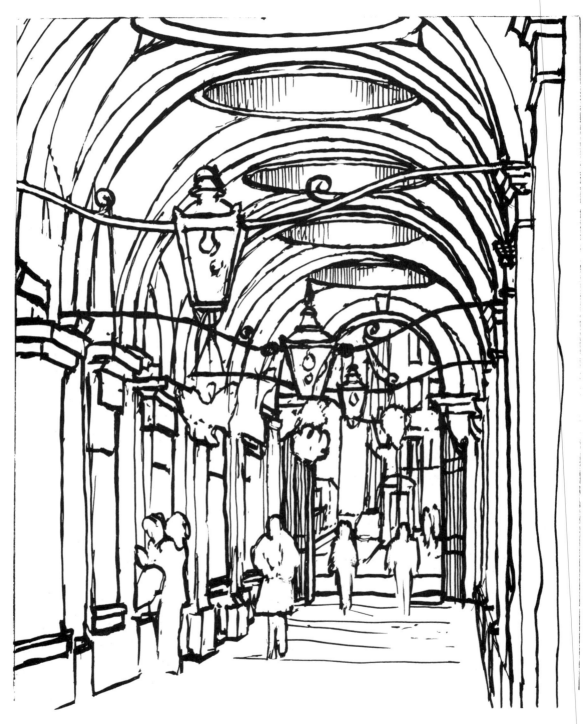

243 *John Nash's arcade of shops off Pall Mall, London*

painting where the perspective of the chair related to the floor is decidedly at fault (Fig. 240), but it was probably a conscious choice, for in his earlier painting of a young Scheveningen woman, the chair and floor relationship is perfectly correct.

Having grown up in Norfolk, the Norwich School of Painters holds a key place in my own life. Cotman uses perspective so soundly that one hardly notices it. 'Storm on Yarmouth Beach' shows a group of fishermen and horses on the sand which sweeps away under the storm clouds above (Fig. 241). His painting of Chirk Aqueduct was chosen to be the image for the poster for an Exhibition of his work at the Victoria and Albert Museum (Fig. 242). The composition, utilising the arches and their strong perspective

244 *Photograph of a brilliant Art Nouveau arcade in Norwich by Skipper, producing a cool aquarium-like calm and tempting the pedestrian to venture further towards the far end*

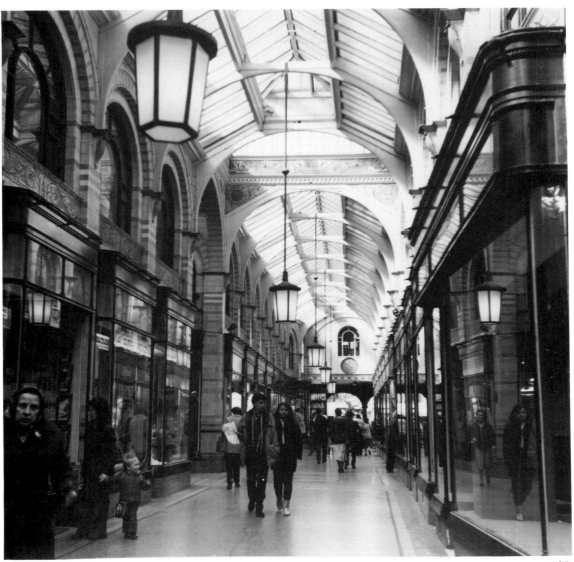

245 *The complex view from the top of a magnificent flight of stairs to the Chapter House, Wells Cathedral*

246 *Even Brunelleschi's dome seems small in the drawing, because of its site at the far end of a street of high buildings, although in actual height it would dwarf all that surrounds it*

plus the quiet reflections, shows how understanding the structure of the subject does not detract from great painting.

There are many examples of architecture where perspective is an emphasised characteristic. Shopping arcades are particularly good examples—for instance Nash's Royal Opera Arcade in London (Fig. 243), Skipper's Royal Arcade in Norwich (Fig. 244) and Mengoni's Galleria Vittorio Emanuele in Milan, are all long narrow constructions, having the quality of receding repetition. So too do the naves of great cathedrals, where pillars and arches march away, or soar upwards to meet in the vault (Fig. 245). Streets with tall buildings produce a similar quality of receding and diminishing structures (Fig. 246).

Sometimes one will find parts of buildings where the architect has purposely used an optical effect to assist him. Sir Christopher Wren, on St Paul's in London, designed niches with heads which might be thought to be more hollow than they actually are (Fig. 247). The Painted Hall at

248 *Notice how the final two arms of Bernini's collonade leading to the façade of St. Peter's diverge as they approach it*

247 *A concave niche at St Paul's Cathedral, London*

The Royal Naval College, Greenwich, was also designed by Wren and painted by Sir James Thornhill. It is a masterful example of illusionist perspective within a real architectural framework. No visitor should fail to look at the fireplace at the right of the High Table; the lower half is real while the upper half is painted, but so convincingly that a cursory glance would miss the fact.

138

In Rome, Bernini designed the final elements of his colonnade leading up to the façade of St. Peter's to diverge! One might suppose them to be parallel but his intention was to try to correct faults in the proportion of the church façade (Fig. 248). Bramante created a whole chancel in S. Maria presso S. Satiro, with false perspective, for the building site failed to provide enough space for a real one (Fig. 249). The Greeks used many tricks to correct what to the eye would have looked uncomfortable (Fig. 250). Flat surfaces are slightly curved, and spaces which might be expected to be equal, are in fact not equal. So artist beware, the visual world is not always what it seems.

249 *The Ground Plan of S. Maria presso S. Satiro in Milan*

250 *Pillars of the Greek temple built at Paestum in Italy. Though two thousand years old and much* *weathered, they still retain a refinement in proportion admired to this day*

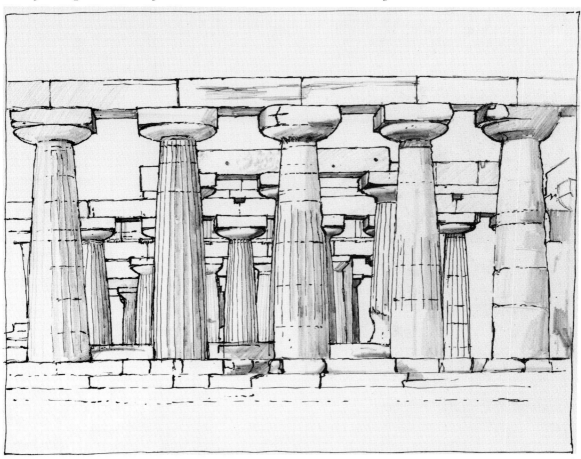

Glossary

The following definitions have been compiled with the artist specifically in mind. In all cases any environment is assumed to be basic and absolutely flat.

Artist The person drawing or painting, who is also observing in order to do so. The picture may be created on site or from imagination.

Construction lines Imaginary or faintly drawn lines used by the artist to link related or unrelated parts, and by so doing facilitate the drawing of the subject.

Converge To come together. Lines known to be actually parallel will appear to approach one another as they recede.

Desert An imaginary flat, smooth, land surface stretching without interruption to the horizon.

Diverge To part. Lines known to be actually parallel will appear to move away from one another as they come forward.

Ellipse A regular oval or a circle seen obliquely which appears to be a regular oval.

Eye level An imaginary line at the height of the observer's or artist's eye and straight ahead. The horizon of a basic desert coincides with this line. The eye level controls all the apparent directions viewed by the observer or artist.

Foreshorten A loose term describing the apparent shortening of a dimension due to visual perspective. Since all three-dimensional objects are likely to show some aspect of perspective, the term tends to be used when extreme shortening takes place.

Ground line The line where a wall or similar object meets the ground.

Guide line A line drawn to establish the direction of an

element. It may be taken right through to its vanishing point (VP) on a horizon. The artist may only draw part of the line where it involves the subject of the picture.

Horizon A line directly ahead at the observer's eye level at which a flat landscape or sea appears to meet the sky. This should not be confused with the skyline.

Horizontal A straight, level line running to left and right. It lies at 90 degrees to vertical.

Isometric A drawing in which all parallel lines are drawn parallel instead of converging or diverging in perspective. Used in drawing offices for planning purposes.

Keystone The centrally placed top stone of an arch or a rib vault. It is sometimes made larger than its neighbours.

Measure Any smooth, straight implement which can be held easily in the hand and by which relative measurements may be made, or angles of lines judged. Actual dimensions such as centimetres or inches are not used.

Oblique A slanting view taken of an object which creates perspective diminution.

Observer The person who may look at the scene and/or look at the picture but may not be the artist (although the artist must be the observer).

Parallel Lines continuously equi-distant. For the artist this is a known condition but rarely seen.

Perspective The art of delineating objects in a picture in order to give the same impression of relative positions and magnitudes as the actual objects do when viewed from a particular point.

Perspective— simple rules Parallel lines will appear to meet at the horizon.

Lines parallel to the ground which are travelling away from and are above the observer's eye level will descend to the horizon.

Lines parallel to the ground which are travelling away from and are below the observer's eye level

	will rise to the horizon.		manner has been given emphasis.
Picture plane	The surface on which the artist draws or imagines the image to exist, e.g. a drawing on a window where the glass becomes the picture plane.	**Three-quarter view**	To view an object or person slightly to one side, i.e. not a totally front or totally side view.
Plane	A flat surface of infinite size. Useful when imagined for its ability to pass through another similar surface.	**Useful horizontal**	A horizontal line parallel to the horizon, but above or below it, which assists the artist in laying out a drawing.
Rake	Slope or inclination towards the stern of a boat.	**Vanishing point**	A point to which all lines which are made parallel appear to converge and meet. In most cases it will lie on the horizon. Exceptions would be rising planes where it would lie above, or descending planes where it would lie below the basic horizon.
Regular	Having parts of the same size, angle or interval.		
Shadow	An area, which, by the intervention of an object between it and a source of light, receives less light in a shape related to the object. The term can also be applied to that part of an object which receives less light.		
		Vertical	Upright, perpendicular, at right angles to horizontal.
		View point	The position of the observer's or artist's eye. It always lies on the basic horizon.
Skyline	A general term for the line where sky and earth appear to meet. According to the terrain, the line may follow hills and valleys. This should not be confused with the horizon.	**Visualise**	To call up a distinct mental picture of something. The artist may have to consider how part of an object appears even though it may be out of sight.
Stylise	An artistic representation where a particular characteristic or	**Voussoir**	Each of the wedge-shaped stones forming an arch.

Index

144